HERB OLSEN'S GUIDE
TO WATERCOLOR
LANDSCAPE

APPROACHING STORM →

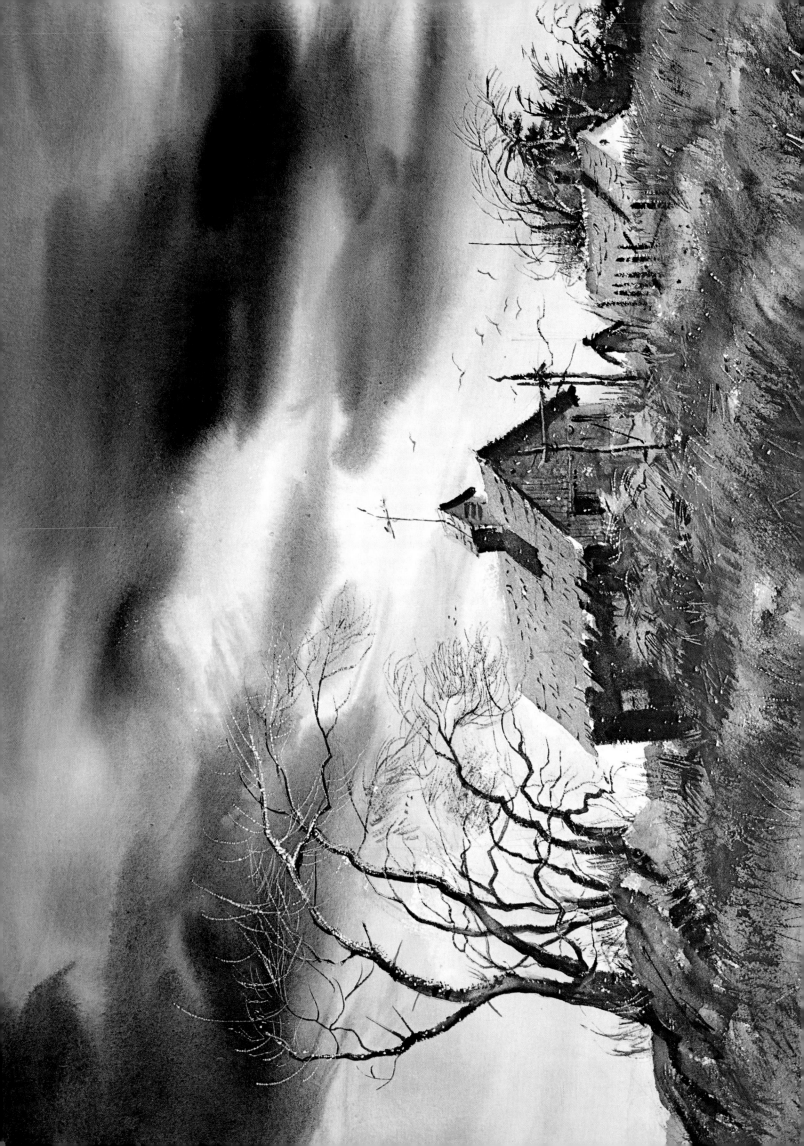

HERB OLSEN'S GUIDE TO WATERCOLOR LANDSCAPE

BY *Herb Olsen*, A.N.A.

GALAHAD BOOKS · NEW YORK

TO MY STUDENTS

Designed by George Buehler

Library of Congress Catalog Card Number: 73-90504
ISBN 0-88365-122-X

Published by arrangement with Van Nostrand Reinhold Company

CONTENTS

COLOR PLATES

FROM THE AUTHOR

The title of this book was chosen after careful deliberation and discussion with the publishers. I feel that it very aptly describes the intent of the book. Firstly, the book gives my own personal viewpoint on solutions to painting problems—I am well aware that there are as many approaches to painting as there are painters. Secondly, the book is principally a reference book—a guide. In writing it, my primary purpose was to explain, by demonstration and illustration, many of the details that present problems to both the amateur and professional artist when painting a landscape in watercolor. No attempt has been made to follow the usual pattern of instruction books that start with elementary fundamentals and develop progressively. This I have already done in WATERCOLOR MADE EASY, in PAINTING THE FIGURE IN WATERCOLOR, and in PAINTING CHILDREN IN WATERCOLOR.

In dedicating this book to my students I do it in all sincerity, because from them I have learned much. I have learned that most of them have many painting problems in common. During my years of experience as a teacher it has been uncanny to note how often the same questions are asked. These are typical: "How do you paint a rock?"; "How do you paint stones?"; "How do you paint clouds, or rain, or puddles, or a field of weeds?" In answer to these and similar questions, I have taken up the problems raised and have tried to show a simple solution to each one. Then, in many instances, I have gone beyond the individual difficult detail to show how the part is incorporated in a whole painting. I have done this to demonstrate that in the course of gaining proficiency in the execution of isolated objects one should not lose sight of learning how to apply that knowledge artistically. Composition, color, values, edges, sensitivity, and originality will never be replaced by expertly executed rocks, or stones, or weeds, or clouds. But often a poorly executed detail will ruin an otherwise good painting because the bad detail is so outstanding that the viewer can see nothing else.

Together with the color reproductions of paintings, careful step-by-step descriptions of the painting procedure are included in this book, to help clarify problems. I suggest that you do some of the steps as exercises and then, as you gain facility, apply the principles to your own work. Do not confine yourself to copying the instructions too literally. Use the *Guide* as it is intended to be used. If followed carefully, the instructions will answer many of your questions and the results will be visible in your work. With the cooperation of my students I have tested all the solutions presented. I find that they do work for them and I hope they will do the same for you.

Sincerely,

Herb Olsen, A.N.A.

7

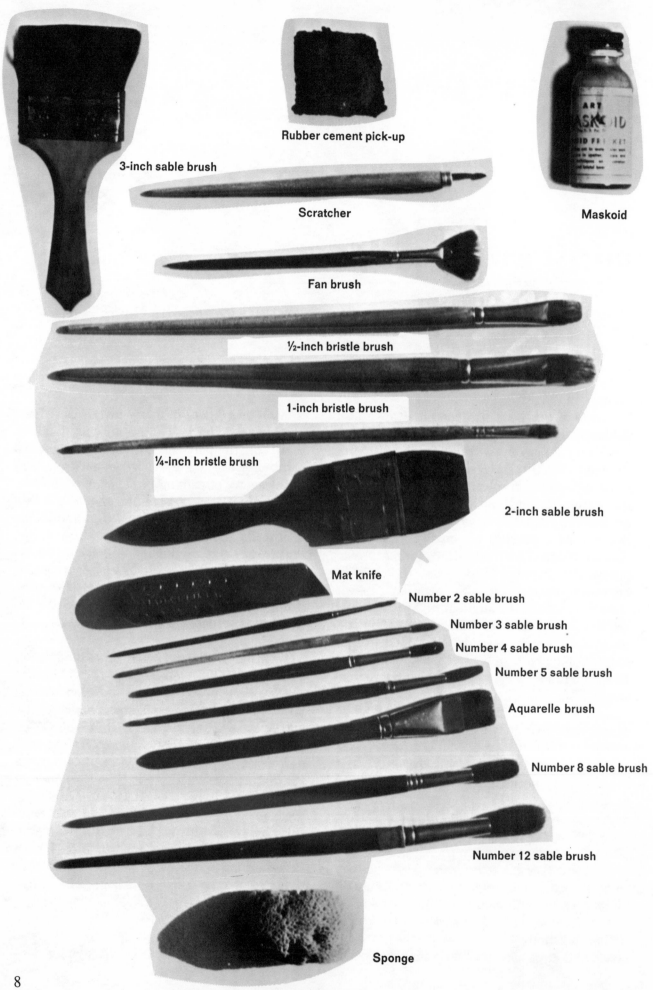

3-inch sable brush

Rubber cement pick-up

Scratcher

Maskoid

Fan brush

½-inch bristle brush

1-inch bristle brush

¼-inch bristle brush

2-inch sable brush

Mat knife

Number 2 sable brush

Number 3 sable brush

Number 4 sable brush

Number 5 sable brush

Aquarelle brush

Number 8 sable brush

Number 12 sable brush

Sponge

8

I. MATERIALS AND HOW TO USE THEM

Much has been said about the four main categories of watercolor materials: paper, color, brushes, and accessories. Each practicing artist develops his own personal preferences through years of experience and experiment. Although we may not agree on the same name-brands—there are many good ones—agreement is certainly unanimous that the best quality is essential to producing good work at any level. I never allow my students to use student-grade equipment; in the long run it is no economy. Undesirable habits can be developed while using such equipment and it may take much valuable time to eradicate these habits.

Paper. A good handmade rag paper is of primary importance. The choice of brands is relatively limited; most popular are AWS, RWS, D'Arches, and Fabriano. There are three different surface finishes—smooth, medium, and rough. Because a smooth paper is slippery and lacks texture I find it more difficult to control. Personally, therefore, I prefer a rough-surfaced paper.

Paper also comes in various weights. A light-weight paper will buckle when wet and it cannot withstand the rough treatment of the sponging, scrubbing, and scraping processes involved in deletions and corrections. For easier handling I advise a heavy paper. My personal choice is D'Arches 300-pound rough. All the full-color paintings in this book were painted on this D'Arches paper.

Colors. There are many good name-brands. Only the best quality pigments are permanent, and permanence is a most important factor. Among high-quality brands, the choice is purely personal. Whether they come in tubes or pans is not important, but most artists prefer to use tubes when painting in the studio. When using tube pigments, and assuming that you have a large surface for a palette such as a white enameled butcher's tray, I advise emptying the entire contents of the tube on the palette at one time. If the color dries on the palette after an extended period of time it can always be moistened; but if it should harden in the tube, which is likely to happen once the tube has been opened, it may be very difficult, often impossible, to get the paint out of the tube. However, I do not suggest emptying the tube on the palette in the cases of Cadmium Red, Cobalt Blue, or Alizarin Crimson because these colors are used in such small quantities. If these pigments should harden in the tubes, they can be softened by a drop of glycerine inserted into the tube with an eye dropper.

Brushes. The ideal situation for a painter is to have a complete set of sable brushes from Number 2 to Number 12. On page 8 there is a photograph of these and additional brushes. This is an expensive and not entirely necessary luxury. When painting on the half sheet you can limit yourself to two brushes—the Number 8, and the useful Aquarelle demonstrated on the next page. However, when painting on the full sheet, the Number 12 is an additional requisite. The ¼-, ½-, and 1-inch short-hair flat bristle brushes used for oil painting are needed for softening edges and for certain other effects. The Fan brush is invaluable for certain effects particularly in the painting of leaves and weeds. Patting on the paint with the heel of this brush creates a softer effect than could be achieved with a regular pointed brush; and because fewer strokes are necessary a static look is avoided. Here I would like to stress a point that should

Aquarelle brush used in upward, stabbing motion to paint stubble.

be remembered whenever applying color—do not force the paint into the paper too vigorously. The brush should always be held so lightly that a gentle tap on the wrist would knock it out of your hand. Try to surface-paint, so that should you want to make a correction, the task of removing the paint will be easier. The effect will be just as good if not better.

Good brushes deserve the best of care. Always keep them clean—wash them with Ivory soap after each painting session. If a brush comes loose from its handle, it can be put together again with Elmer's Glue or Dupont cement. Place the cement or glue in the metal sleeve and on the wooden handle, then push them together. Do not use mended brushes for 24 hours.

Accessories. This category of materials is perhaps the most personal of the four. Certain fundamental requisites are standard equipment: a soft, small, fine-textured cosmetic sponge; a water container large enough to accommodate hand and sponge; a large-surfaced palette, preferably a white enameled butcher's tray; a hand mirror; kneaded and sanded eras-

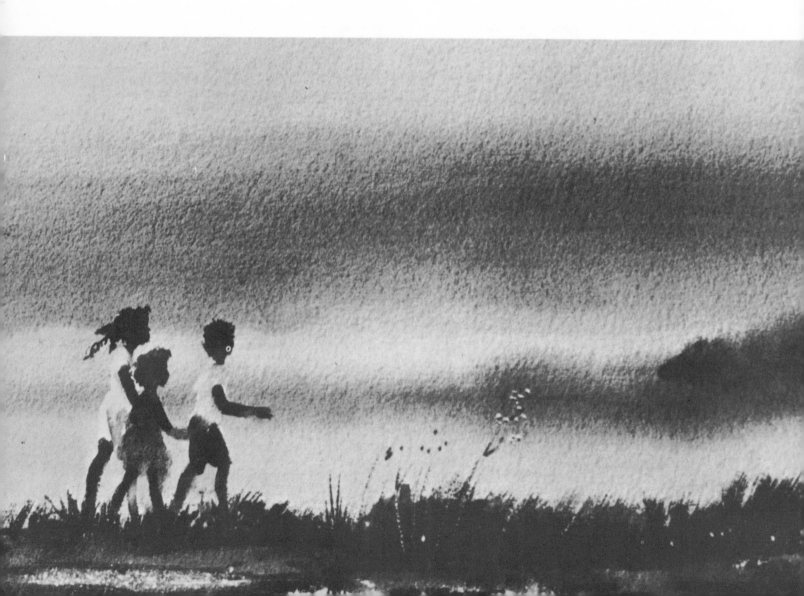

ers; drawing board; sketch pad; HB, 2B, and 6B pencils; mat knife; blotters.

Many invaluable aids can be added to such a basic list. I feel that anything an artist uses to create the effects he wants is within artistic bounds. A pure watercolorist is limited to a degree by not using white in his work, but for many years he has used masking tape to help maintain his whites. A much more flexible and less limited medium for this purpose is *Maskoid*, a liquid masking solution. This medium is so important and helpful that I have decided to devote an entire section to it and its uses, (page 14).

A large sheet of *acetate* is a great boon to the artist. It will help prevent many unnecessary mistakes. If the artist is not quite certain whether a figure, or a tree, or a building, let us say, would add or detract from the composition, the object can be painted on a sheet of acetate. This sheet can be laid over the painting so the effect can be considered. Similarly, the proportion of a doubtful element or object can be determined.

Making corrections. This problem in watercolor has long been exaggerated by those who are not familiar with the medium. Color can be successfully washed out with a sponge if the sponge is carefully kept clean, is properly manipulated, and is used with the aid of *enamel-backed blotters*. The method is illustrated on page 12. Caution: *never* use reversible blotters. Protect the surrounding area with blotters; with a damp—not wet—sponge, stroke the area to be deleted carefully once, then blot with another blotter and wash the sponge in clean water. Repeat until the area is reasonably clean. The action is—wash sponge, stroke, and blot—wash sponge, stroke, and blot. Be sure the water is colorless, or you will be washing color back into the paper.

Heel of Fan brush used in patting motion to paint leaves.

Another most helpful accessory in removing color is called a *scratcher*. This is an inexpensive tool that looks like an old-fashioned writing pen with a blunt point. If carefully used, it can remove color without any damage to the paper, such as often happens when a mat knife is used for this purpose. The scratcher is most successfully used in small areas, because of the tedium involved in its use, but with great patience even large areas of paint can be removed. When the scraped area is repainted, no sign of the scratching can be seen. A word of caution—do not apply too much pressure. See page 13.

Mending a broken brush.

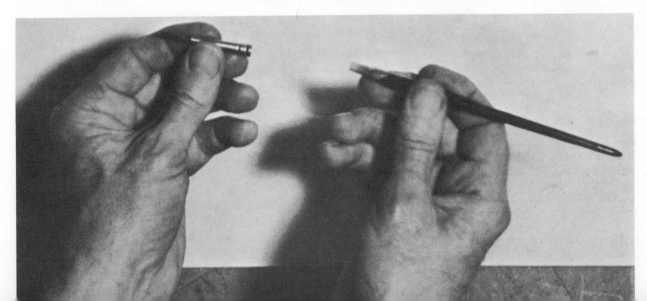

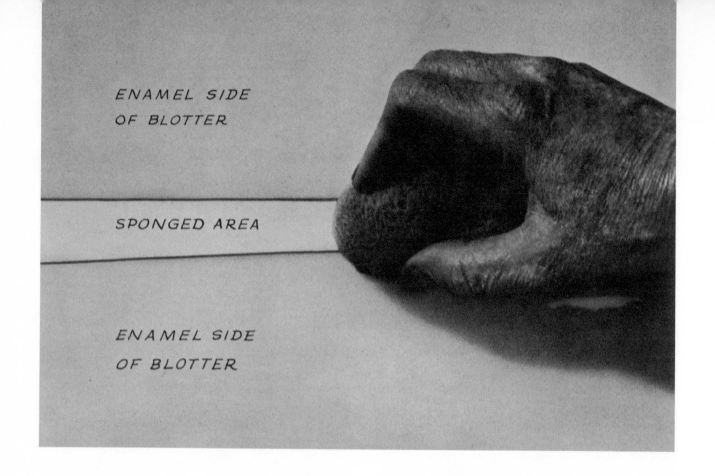

ENAMEL SIDE
OF BLOTTER

SPONGED AREA

ENAMEL SIDE
OF BLOTTER

MAKING CORRECTIONS WITH BLOTTERS AND SPONGE

SPONGED AREA

Study the example shown in the illustrations on this page. Here, before sponging, the wall and the siding door were of the same value. To lighten the wall and provide contrast, a section of the paint was carefully sponged away. Enamel-backed blotters were placed at both sides of the area before sponging. After the correction was finished the area was allowed to dry. Then the shadow cast by the lamp was painted over the sponged area.

MAKING CORRECTIONS
WITH THE SCRATCHER

Here the scratcher is used to bring back high-lights on the wash and the washline, which were lost in the background washes.

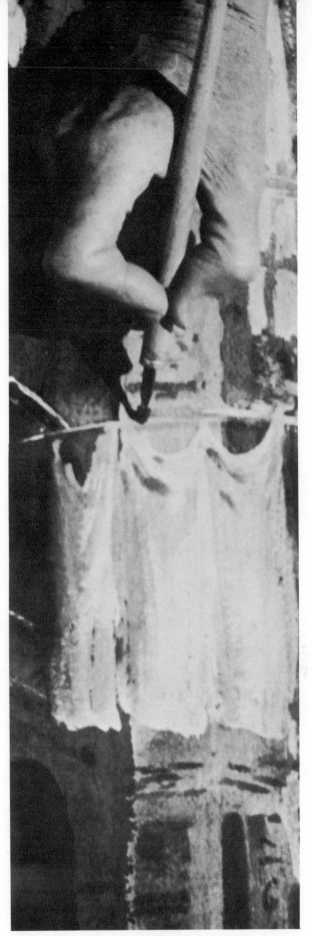

Using the scratcher.

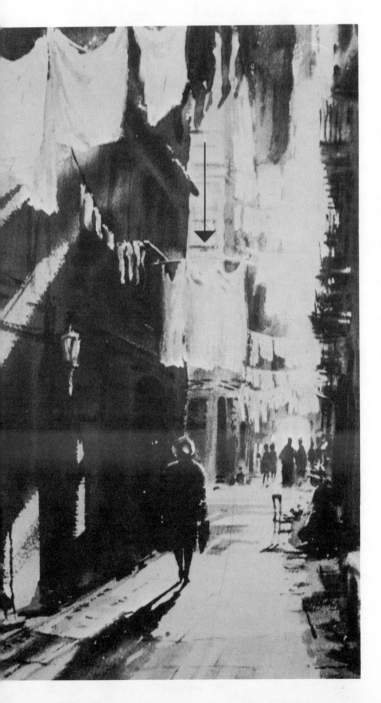

13

Maskoid is a neutral gray masking liquid of a consistency that makes its application by brush easy and convenient. Maskoid dries quickly to form a protective coating and is easily removed with a rubber cement pickup.

When executing a watercolor painting it is often necessary or desirable to protect parts of the drawing from broad washes of color. This is easily accomplished by applying Maskoid to these portions. While the Maskoid is on, the washes can be handled without interruption, maintaining fluidity and freedom. When it is removed, the result is that crisp spontaneous "whites" of the paper show on your painting, adding scintillating effects.

Care should be used in the application of Maskoid. Always shake the jar thoroughly before applying. Do not "slap" it on at random. Paint it on carefully—exactly the way you would paint color. It does not need to be applied thickly. Use just enough to protect the paper.

Applying Maskoid. Brush is held in writing position.

II. MASKOID

When Maskoid is used to cover an area that involves a good deal of drawing, this area should first be painted with a wash of color. The wash will serve as a protective covering for the pencil drawing which would otherwise be rubbed out during the removal of the Maskoid with the pickup.

Never use a good brush for applying Maskoid. The size of the brush will depend on the size of the area to be covered, just as in applying color. It is not advisable to apply Maskoid in direct sunlight, and it should not be allowed to remain on the paper longer than a month. After that it tends to become "tacky" and very difficult, sometimes impossible, to remove. If, after the Maskoid has been removed, edges appear too hard, soften them with a bristle brush.

Be careful to keep the bottle of Maskoid covered tightly at all times when not in use. Even if you intend to use it again within a few minutes, keep it covered in the meantime or it will coagulate.

Apply the Maskoid in the following manner:

1. Wet your brush and soap it on a cake of Ivory soap.

2. Dip the soaped brush into the jar of Maskoid and wipe the excess on the side of the jar.

3. Proceed to apply the Maskoid to the desired areas of the paper. Hold your brush in a writing position as shown. Repeat the soaping from time to time. In a little while you will become accustomed to soaping and dipping the brush.

4. If your brush should harden, repeat the soaping and attempt to loosen the hardened Maskoid with your fingers. The insoluble particles that form can be removed by immersing the brush in Maskoid Remover or Bestine for several hours. Follow by washing the brush in soap and water.

5. Maskoid dries to a dark gray, which indicates that it has formed a protective membrane or coating.

6. After all colors have dried, remove the Maskoid by rubbing it with a rubber cement pickup as shown.

The illustrations on these two pages demonstrate how valuable Maskoid is not only when painting a complicated subject such as the ship's rigging shown, but also for simpler subjects such as the rowboat.

Removing Maskoid with pick-up.

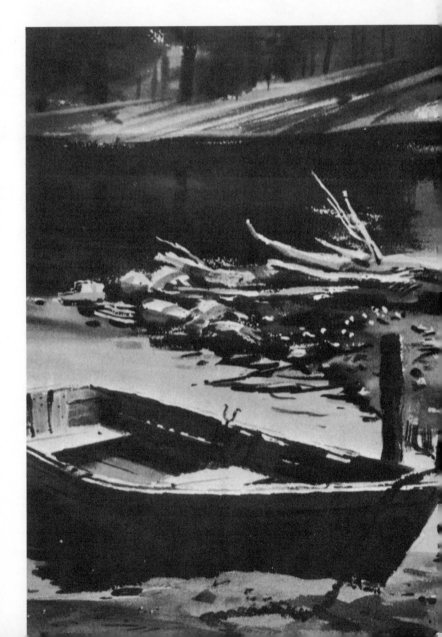

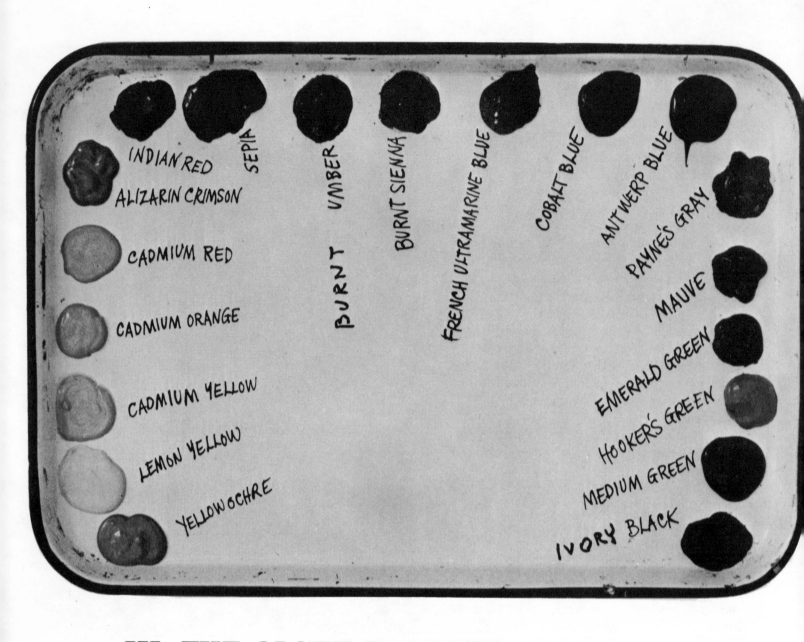

III. THE OLSEN PALETTE

For my palette I use a large white enameled butcher's tray, 19 inches by 13 inches. This holds a wide assortment of pigments in generous amounts, leaving ample room for mixing colors. As you see, I arrange my colors from warm to cool. This grouping works very well for me, but other arrangements may suit you better. However, no matter how you arrange your colors you should have a definite plan so you can reach for a color without fumbling. Be sure to keep plenty of pigment on your palette so you won't run out of color in the middle of a wash.

It is important to know that in the case of certain equivalent blue and green colors names

vary according to the manufacturer. In the paintings in this book I used Rembrandt but there are excellent equivalents manufactured by Grumbacher and Winsor Newton. This should be kept in mind as you follow my painting procedures. Below is a list of color equivalents.

BLUE: Rembrandt *Permanent Blue* or *New Blue*
 Grumbacher *French Ultramarine*
 Winsor Newton *French Ultramarine*
BLUE: Rembrandt *Antwerp Blue*
 Grumbacher *Thalo Blue*
 Winsor Newton *Winsor Blue*
GREEN: Rembrandt *Rembrandt Green*
 Grumbacher *Viridian*
 Winsor Newton *Viridian*

16

IV. BLENDING AND MIXING COLORS

Throughout this book you will find, in the step-by-step descriptions, instructions to blend color on the paper, mix color on the paper, or mix color on the palette. Each of these directions produces a different result; this may sound perplexing to those who are not familiar with the effects achieved by these different means of mixing color. On page 19 I have demonstrated each method. In time and with a little practice you will know automatically when to use one or the other. One of the most important things to remember in handling color is to clean your brush so that color is not carried over unintentionally—sometimes with disastrous results. Take care also to keep the water in your container clean. Dirty water produces dirty color. I strongly urge using a large container such as a small bucket—one large enough to permit washing out a sponge.

BLENDING AND MIXING COLORS

TECHNIQUES FOR PAINTING SHADOWS ON BUILDINGS

When painting out-of-doors there is only one source of light, and that is the sun. Shadows cast on a building by the sun are the same color as the building itself, only deeper. Such shadow tones can be correctly achieved by merely adding Black or Sepia to the original color. The examples shown on the color plate below demonstrate the simplicity and effectiveness of this method.

1. Cadmium Red barn.

2. Add shadows, using Sepia and Cadmium Red mixed on the palette. Add deep shadows, using Black and Cadmium Red mixed on the palette.

3. Cadmium Yellow house.

4. Add shadows, using Sepia and Cadmium Yellow. Add deep shadows, using Black and Cadmium Yellow.

5. Hooker's Green barn.

6. Add shadows, using Black and Hooker's Green mixed on the palette.

7. White buildings.

8. Add shadows by blending Burnt Sienna into Cobalt Blue on the paper. Because the buildings are white, the shadows are reflected color from the sky (Cobalt Blue) and the ground (Burnt Sienna). If the white buildings were in a shaded green area, the shadows would be reflected green—if they were in an autumnal setting, the shadows would be the reflected orange and yellow tones of the autumn foliage.

A VARIETY OF USEFUL TECHNIQUES

You will find that these techniques can be applied to a wide range of subject matter in addition to the examples shown on the color plate below.

1. Blending a sky. Paint from the bottom up, using Yellow Ochre with a touch of Orange, blended on the paper. Then paint from the top down using Permanent Blue and Sepia mixed on the palette. Blend the blue tone into the yellow tone.

2. Background of trees. Blend the tree colors on the paper—Burnt Sienna, Green, Burnt Umber, Hooker's Green, Sepia. Mix Permanent Blue and Indian Red on the palette, for shadows.

3. Tree trunks. Mix Permanent Blue and Sepia on the palette. Use this as the foundation tone.

4. For bark, paint over the blue with Burnt Sienna, Sepia, and Black, mixed on the paper.

5. Details for a winter scene. All the colors here are mixed on the paper. Use Burnt Sienna and Permanent Blue for the weeds. Use Burnt Sienna and Black for the rocks.

6. Add shadows, using Permanent Blue and Sepia mixed on the palette.

7A. Permanent Blue and Sepia, mixed on the palette—dark to light.

7B. Permanent Blue and Indian Red, mixed on the palette.

8. For these shadows, mix Lemon Yellow and Black on the palette.

BLACK AND CADMIUM YELLOW

CAD. SEPIA AND CAD YELLOW

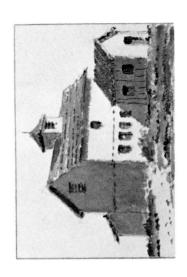

ADD SEPIA AND CAD. RED FOR SHADOW

ADD BLACK AND CAD. RED FOR SHADOW DEEPEN

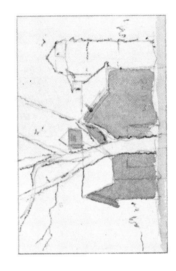

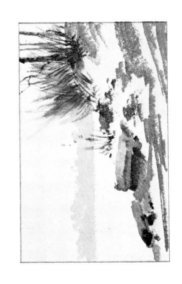

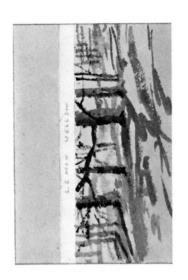

LEMON YELLOW

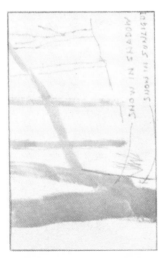

SNOW IN SHADOW

SNOW IN SUNLIGHT

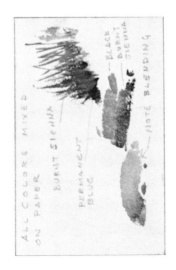

ALL COLORS MIXED ON PAPER

BURNT SIENNA

PERMANENT BLUE

BLACK

BURNT SIENNA

NOTE BLENDING

V. THE FIRST THAW

The appealing fluidity and fresh transparency of watercolor lend themselves particularly well to the painting of puddles with their interesting reflections. When properly handled, I believe that there is no other medium in which these effects can be as fascinating.

The painting THE FIRST THAW is primarily a lesson in how to produce some of these desirable effects. The original picture was painted on 300-pound D'Arches paper and is 22 by 30 inches. The color reproduction will be found on page 29 and should be referred to frequently when following the step-by-step description of painting procedure. Below is a complete list of the materials used.

PAPER: D'Arches, 300-pound
PENCIL: HB
BRUSHES: Aquarelle Brush
2-inch inexpensive sable brush
Numbers 5 and 8 sable brushes
½-inch short-haired sable brush
MASKOID
COLORS: Yellow Ochre
Medium Orange
Permanent Blue (or New Blue)
Sepia
Burnt Sienna
Antwerp Blue
Indian Red
Ivory Black

THE FIRST THAW

PAINTING PROCEDURE STEP-BY-STEP

Step 1. A careful pencil sketch drawn lightly with an HB pencil.

Step 2. Sponge sky area with clean water to remove any possible greasy film, sometimes present in a handmade paper. While the paper is wet, paint the sky area with a 2- or 3-inch brush, using Yellow Ochre and a touch of Medium Orange. Start at the horizon line (see pencil sketch) and, with horizontal strokes, cover the paper to top. With a clean brush and while the paper is still wet, paint from the top of the paper, halfway to the horizon line (always with horizontal strokes) —this time using Permanent Blue and Sepia mixed on the palette. Let the colors blend on the paper without brushing.

Paint the road area lightly with the Aquarelle brush, using the same colors, Yellow Ochre, Orange, Permanent Blue, and Sepia, mixed on the paper. Reserve accents for later steps. Leave the paper unpainted for puddles.

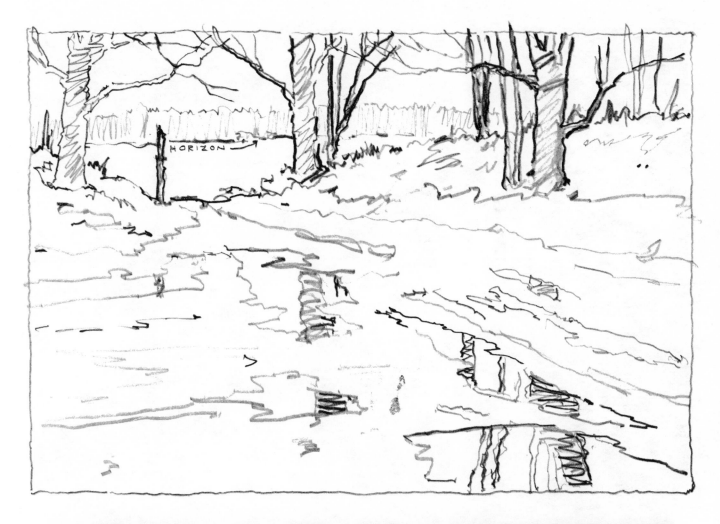

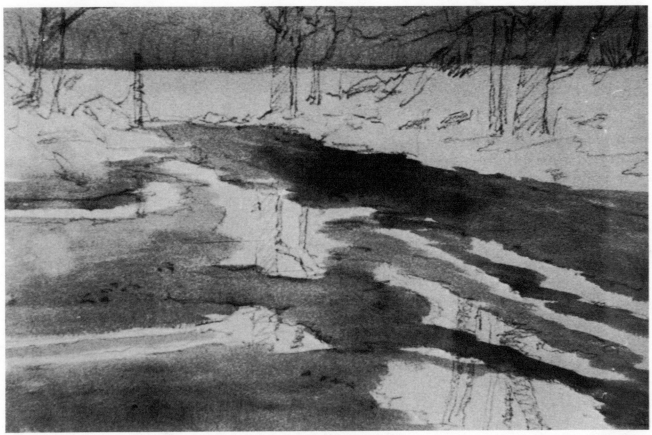

23

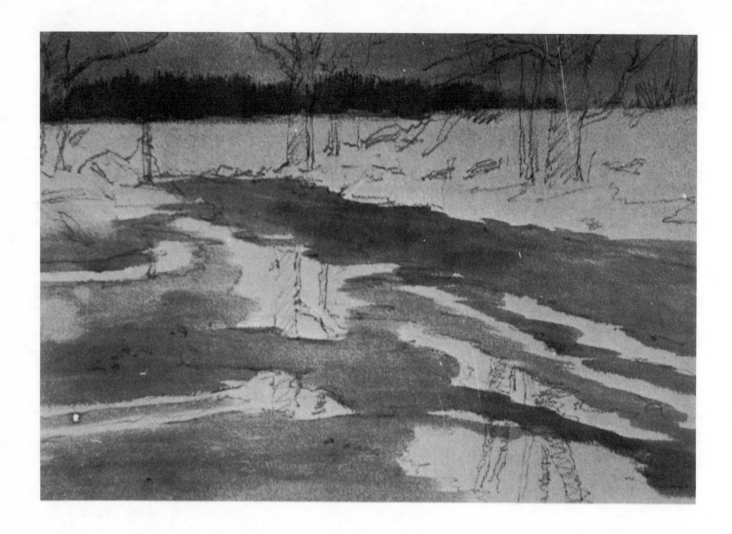

Step 3.　Paint the background woods above the horizon line with Permanent Blue and a little Yellow Ochre applied with the flat side of the Aquarelle brush (see page 10). Use upward strokes, and when the area is covered, turn the brush to the chisel edge and dab the top line to create the feeling of tree tops and to avoid a hard, pasted-in look at the edge.

Step 4. When the woods area is dry, paint the trunks of large trees with a quite dry wash of Permanent Blue and Indian Red, mixed on the palette, leaning towards the blue (see page 19). Color is applied with a flat, short-haired ½-inch sable brush. Let dry. Then paint (as dry as possible in order to retain the textures of the trees) over the Permanent Blue with Sepia, Burnt Sienna, and Black, mixed on the paper at random. Allow some blue to show through for effects of snow (see Color Plate, page 29). For the smaller trees use a Number 8 brush and for twigs a Number 5.

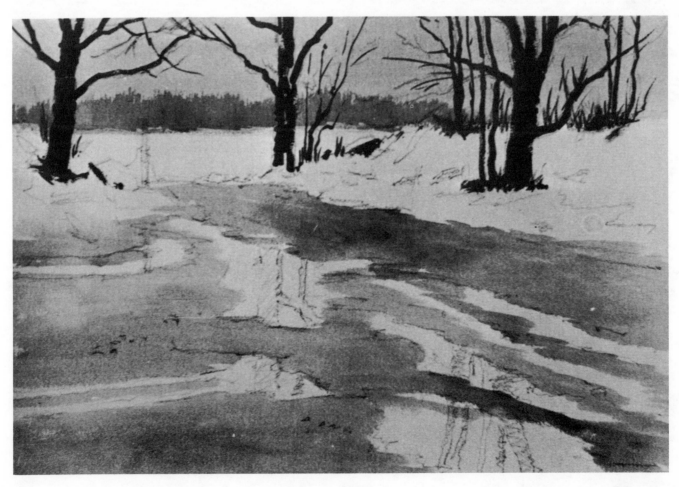

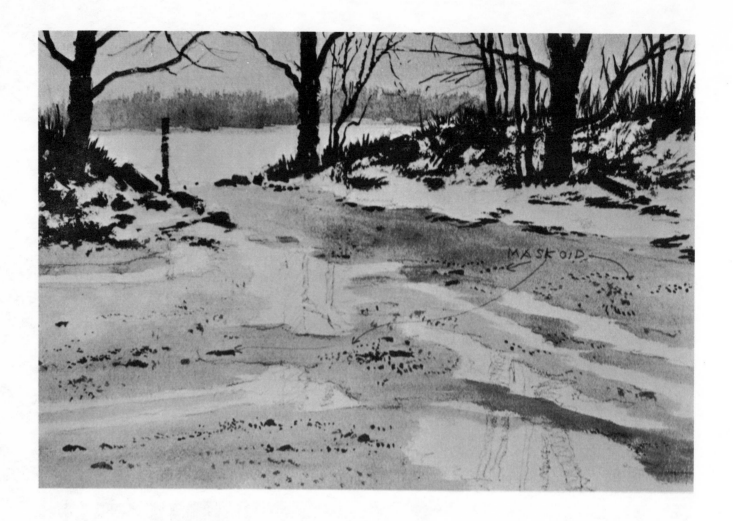

Step 5. For the patches in the snow use a Number 8 round sable brush, and apply Burnt Sienna, Yellow Orange, and Sepia, mixed on the paper (see page 19). Continue to paint "dry." Use Black sparingly, and remember to clean your brush after each application of color. Change the water frequently, always keeping in mind that dirty water will "muddy" your color as will a dirty palette.

Apply Maskoid for stony areas as indicated. Allow plenty of time for the Maskoid to dry so there will be no danger of wet Maskoid adhering to your good brushes. When thoroughly dry, continue adding twigs.

Step 6. For overpainting of the road, use the flat side of the Aquarelle brush and stroke horizontally with Sepia, Burnt Sienna, Black, and Antwerp Blue, mixed on the paper. Paint right over the dry Maskoid, but try to retain some of the original first wash.

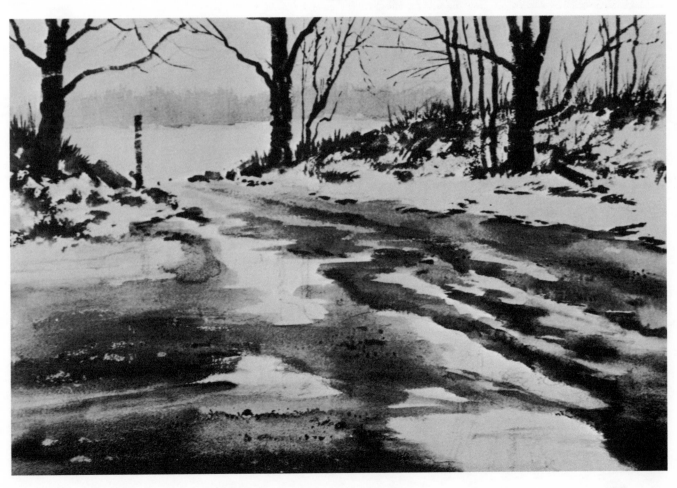

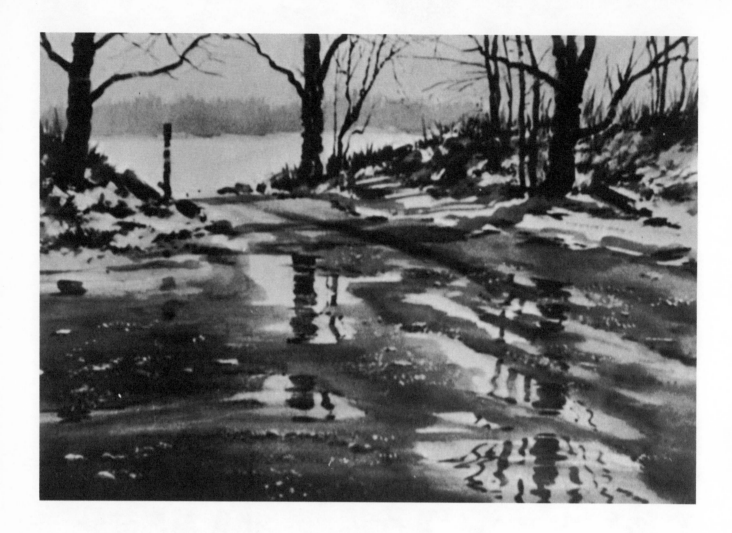

Step 7. Finishing touches. Remove Maskoid
when the painting is thoroughly dry. Then add
accents, such as certain edges of puddles and
stones, with darker notes of the original colors.
For reflections of trees in puddles, use the same
colors and brushes with which the trees were
painted. Add shadows, using Permanent Blue
mixed sparingly with Indian Red on the palette
(refer to color blending on page 19). Apply the
color darker at the base of the trees and lighter
as the shadows cross the road.

Step 8. Finished painting (see the painting in
color opposite). Add numerous twigs to the
trees with the Number 5 brush. Deepen reflec-
tions of the trees in the center of the painting.
Then with a ½-inch flat brush stroke the ruts
in the road as indicated, with the colors used in
Step 6. Put a light wash of Yellow Ochre in the
puddles in the foreground, and add blue to the
puddle on the left. Add barbed wire to the post
(see page 122).

THE FIRST THAW

VI. TWILIGHT

The two paintings, THE FIRST THAW on page 29 and TWILIGHT, opposite, were painted at almost the same spot, but on different days. THE FIRST THAW was painted on a slushy winter day, and TWILIGHT on a crisp winter day. The difference in composition was achieved by changing the placement of the horizon line, thus creating two completely different views—one featuring the foreground, the other the background. To have incorporated the entire scene into one picture would not have been plausible artistically; artists often try this sort of thing with the result that their painting is actually two pictures in one, with the horizon line dividing it almost in dead center. An artist so often goes to a certain locale to paint and sees only one picture where actually there are two. Learn to take advantage of every possibility.

VII. PENCIL SKETCHES

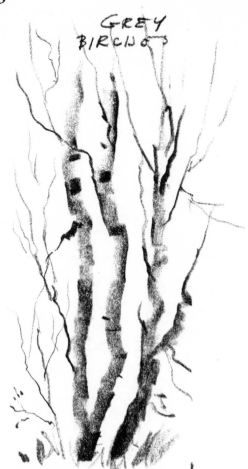

GREY BIRCHES

The first step in planning any composition, whether from life or from a photograph, is to make a rough pencil sketch, see pages 34 to 39. The rough sketch serves to block in the large over-all pattern with no reference to detail. It is usually advisable to make several of these in order to determine the best possible composition. See the Central Park sketches on page 79 for a good example of recording a variety of possibilities. I cannot overemphasize the importance of this approach to planning a painting. It is not time-consuming and it minimizes the danger of ending with a faulty composition.

Pencil sketches serve many other purposes for the water-colorist. They are an invaluable aid when a camera or paints are not available to record a scene. Together with pencil notations made for the colors (see Barn below), they serve as the only guide for both color and composition in such cases. This type of sketch is generally more detailed and finished than is usually necessary. In making a drawing of this kind use a soft pencil—preferably 6B or 8B, or a layout pencil, sharpened to a chisel edge. This makes it possible to put in large areas in broad strokes and establish the values for the painting.

FOR TREES START AT BASE AND PUSH THE PENCIL UP TWISTING IT FOR IRREGULAR EFFECT

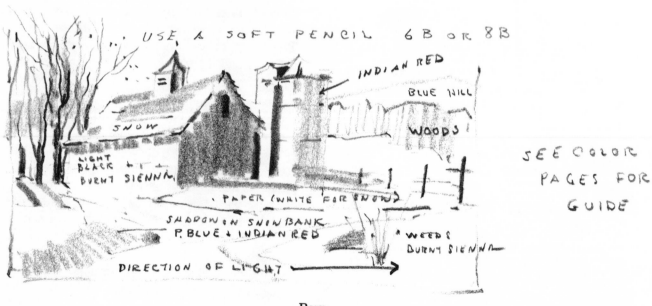

USE A SOFT PENCIL 6B OR 8B

INDIAN RED

BLUE HILL

WOODS

SNOW

LIGHT BLACK + BURNT SIENNA

PAPER (WHITE FOR SNOW)

SHADOW ON SNOWBANK P. BLUE + INDIAN RED

WEEDS BURNT SIENNA

DIRECTION OF LIGHT

SEE COLOR PAGES FOR GUIDE

Barn.

34

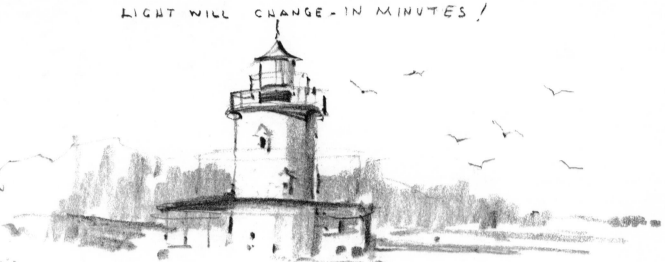

MAKE 3 MINUTE SKETCH. THEN MAKE COLOR NOTES
THEN TAKE A SNAP SHOT FOR LIGHT AND SHADE
LIGHT WILL CHANGE - IN MINUTES!

Lighthouse.

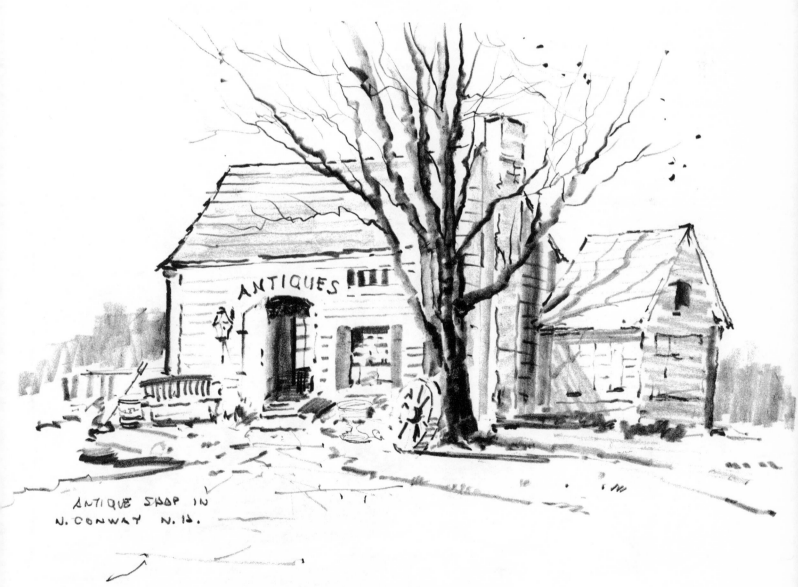

ANTIQUE SHOP IN
N. CONWAY N. H.

Antique Shop in North Conway, New Hampshire.

35

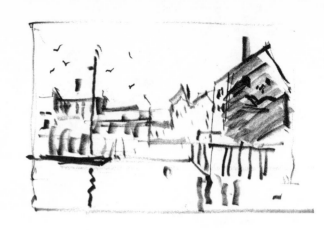

Coast scenes.

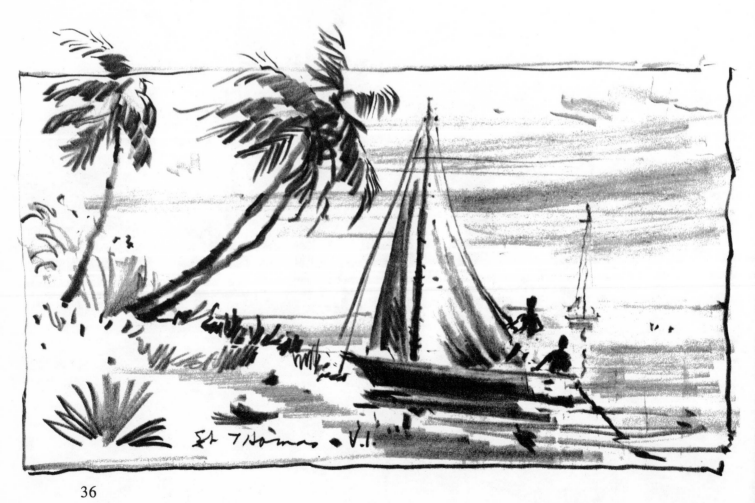

St Thomas · V.I.

36

THE COAST MAKES AN INTERESTING
LANDSCAPE

SHAPES TO ESTABLISH
COMPOSITION

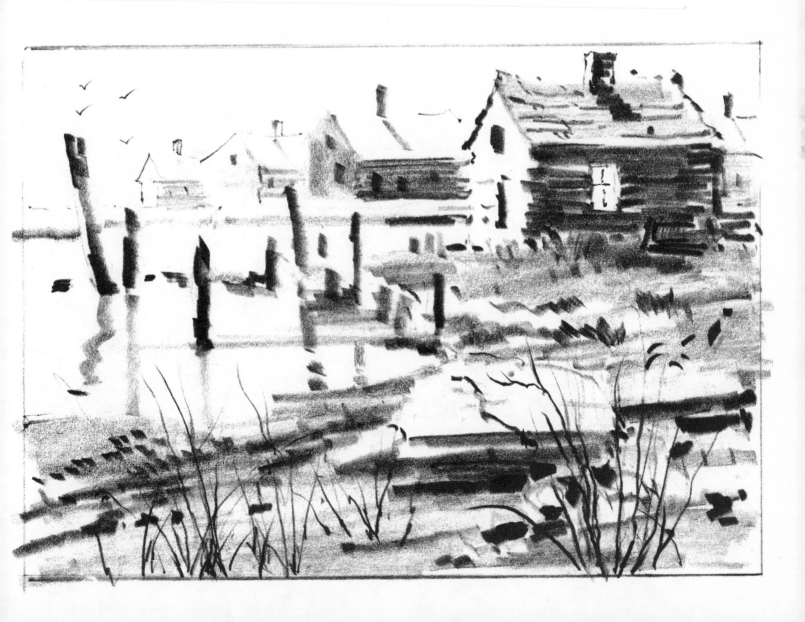

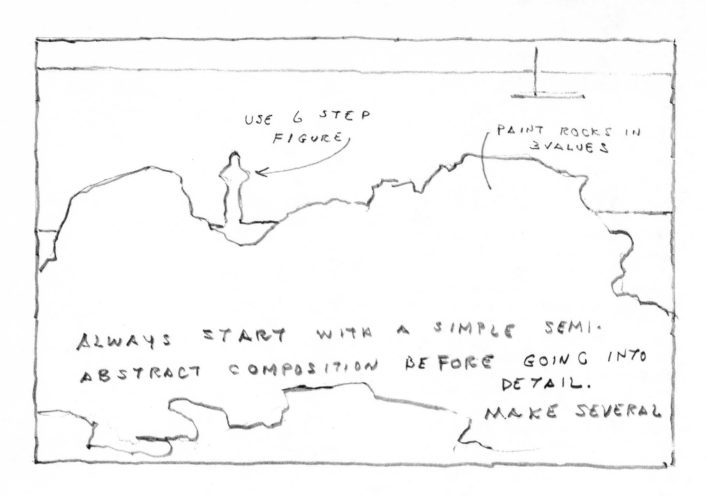

Boy on rocks. Rocks overpower the figure.

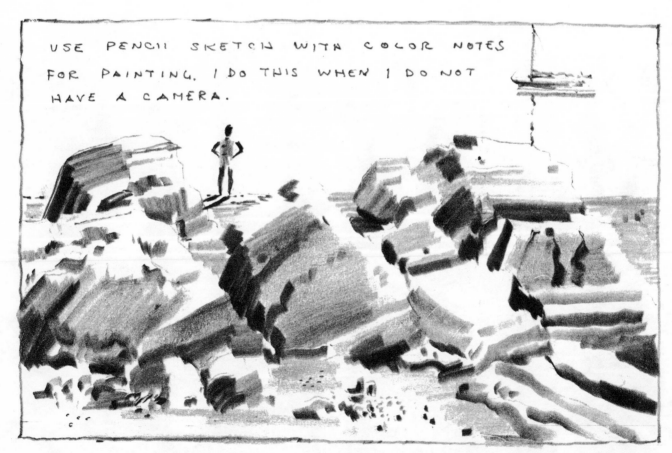

THE NIGHT SCENE

A rather isolated but helpful use for the pencil sketch is in preparation for a night scene. Since a night scene quite obviously cannot be photographed without professional knowledge and equipment, the pencil sketch must serve as data for composition and color, and since it is difficult to distinguish primary colors at night the artist will differentiate chiefly between warm and cold colors rather than between the particular colors in the scene, as he would in daylight. I once heard of an artist who tried to paint a night scene outdoors with the help of a flashlight. The results were disastrous, and the idea is not recommended. But a pencil sketch with color notes *is* recommended.

Night scene.

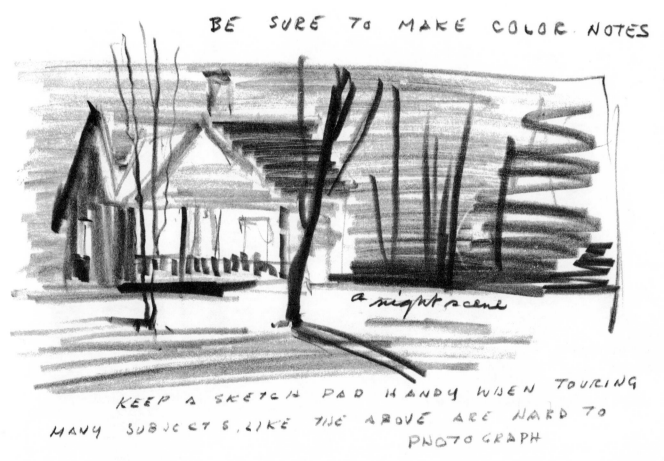

a night scene

BE SURE TO MAKE COLOR NOTES

KEEP A SKETCH PAD HANDY WHEN TOURING
MANY SUBJECTS, LIKE THE ABOVE ARE HARD TO
PHOTOGRAPH

39

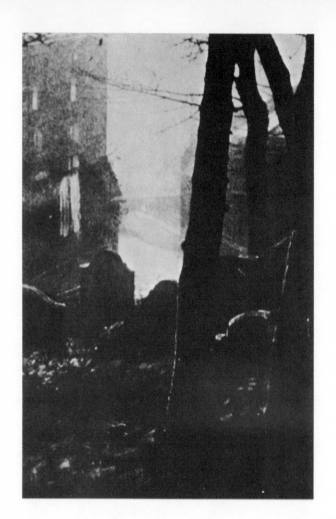

VIII. MORNING FOG

I often use a rough pencil sketch to help me catch the atmosphere of a spot and to become better acquainted with it. It is a sort of warming-up process, even if I have already taken a photograph from which I will work at a later date. Such was the case in the painting of MORNING FOG, shown opposite. This is primarily a mood painting, and although my photograph was a great help for details, I felt that it had not captured the atmosphere as well as my rough pencil sketch. Notice that I added the figure of a man to emphasize the eerie quality of the scene. I strongly advocate developing the habit of making these quick sketches—they pay off.

THREE MINUTE SKETCHES

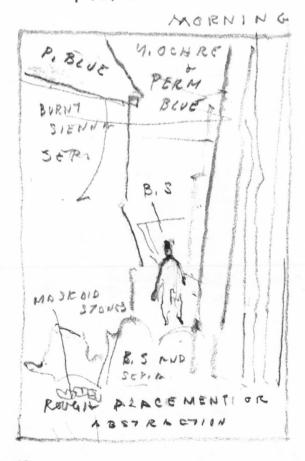

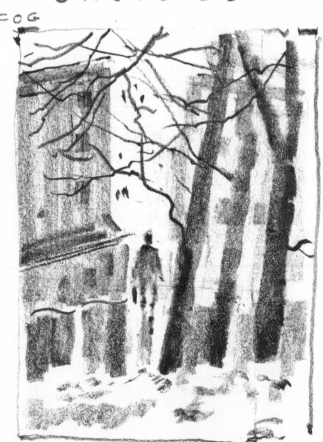

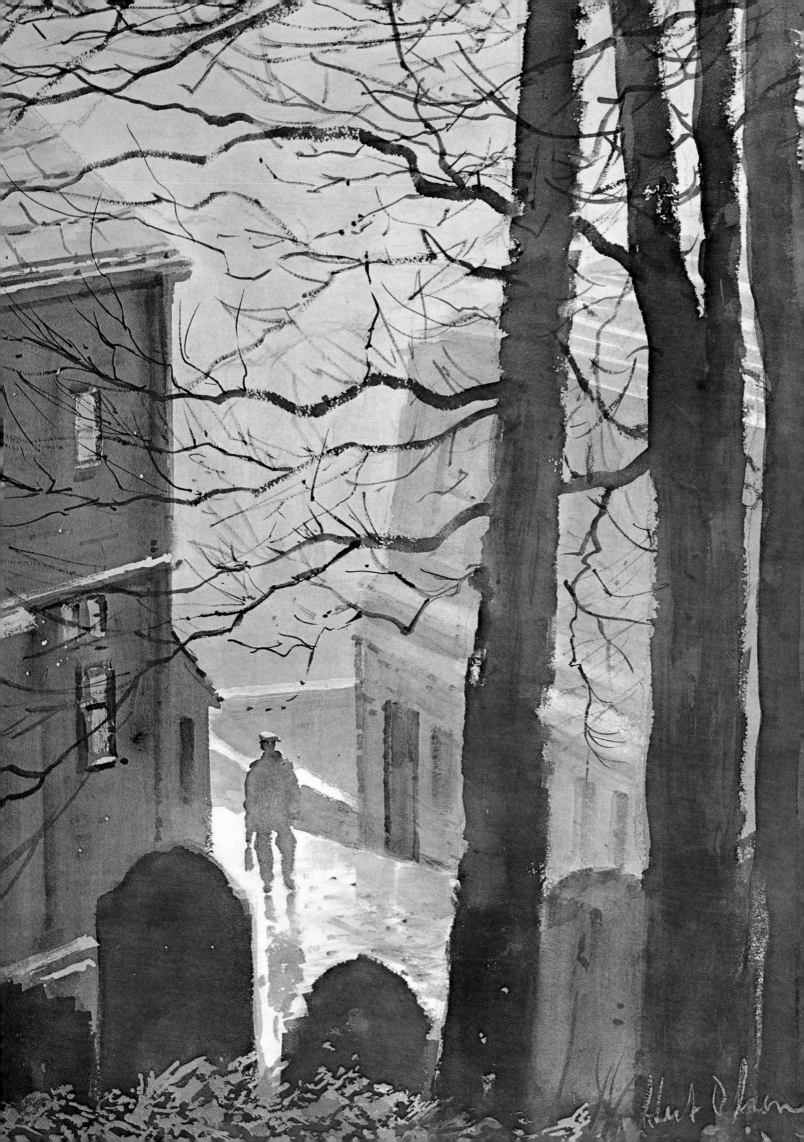

MORNING FOG

IX. CHANGING THE SCENE

There was a time when it was considered unethical to paint a scene that was not a facsimile of the original. This philosophy developed a school of monotonous and stilted paintings. A newer school of thought believes that liberties can and sometimes should be taken where nature can be improved upon. Just because "it is there" does not mean that the artist has to reproduce it exactly that way. The camera does a better job.

But often just what kind of change constitutes improvement does not occur to the less experienced artist. There are countless possibilities. For example, a telephone pole could be converted into a tree, a hill could be changed into a waterfall, a house can be added or moved or deleted to improve the composition.

The challenge of converting what one sees into a more imaginative scene presents an exciting opportunity for a new experience and can prove intensely stimulating. Furthermore, the resultant painting is then truly your creation.

On the following pages are two examples of changing a scene which illustrate my viewpoint.

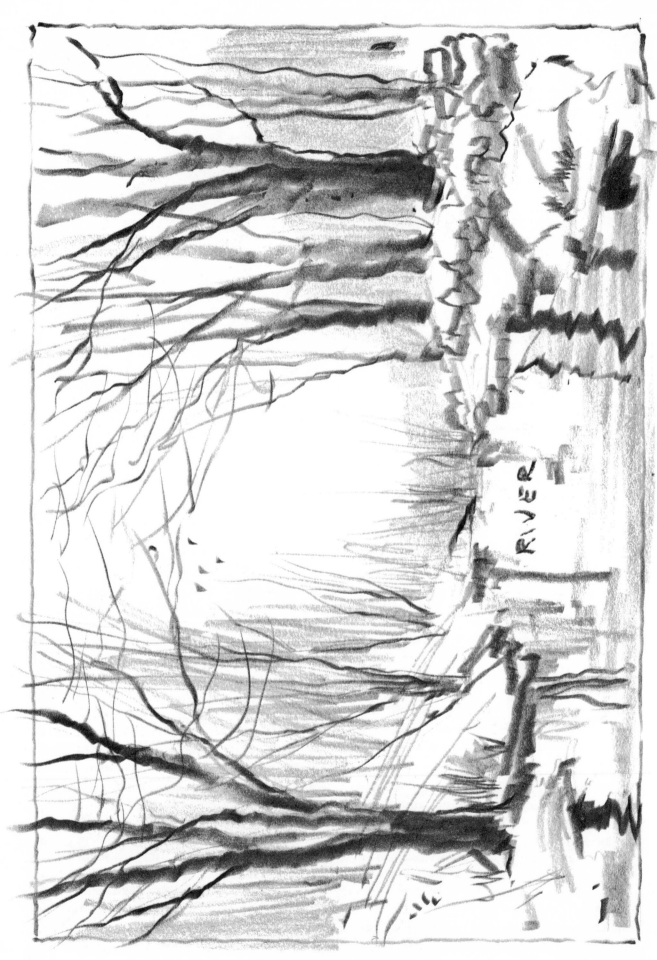

The River (original scene).

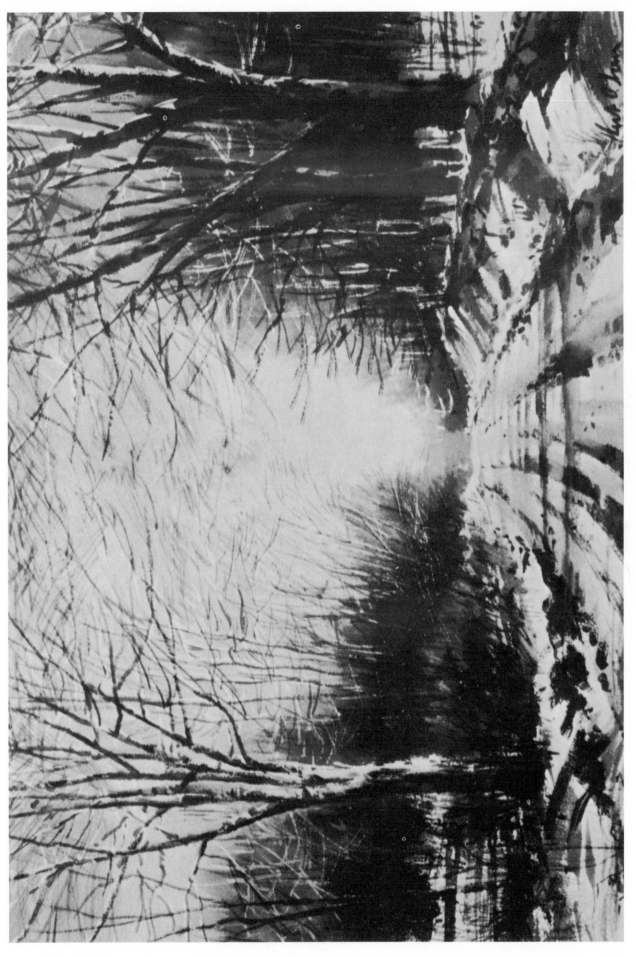

Changing the Scene.

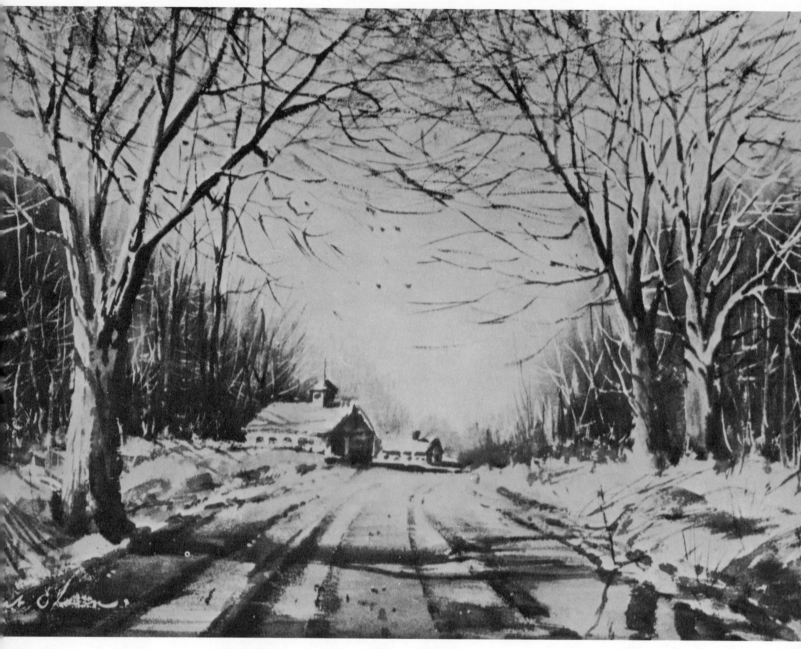

Winter.

WINTER

As you can see here I changed my original
sketch of WINTER from a river scene to a road
scene, adding buildings at the turn. A WINDING
STREAM, shown on page 50, is a reversal of this
process. In both cases I think the changes im-
proved the pictures.

46

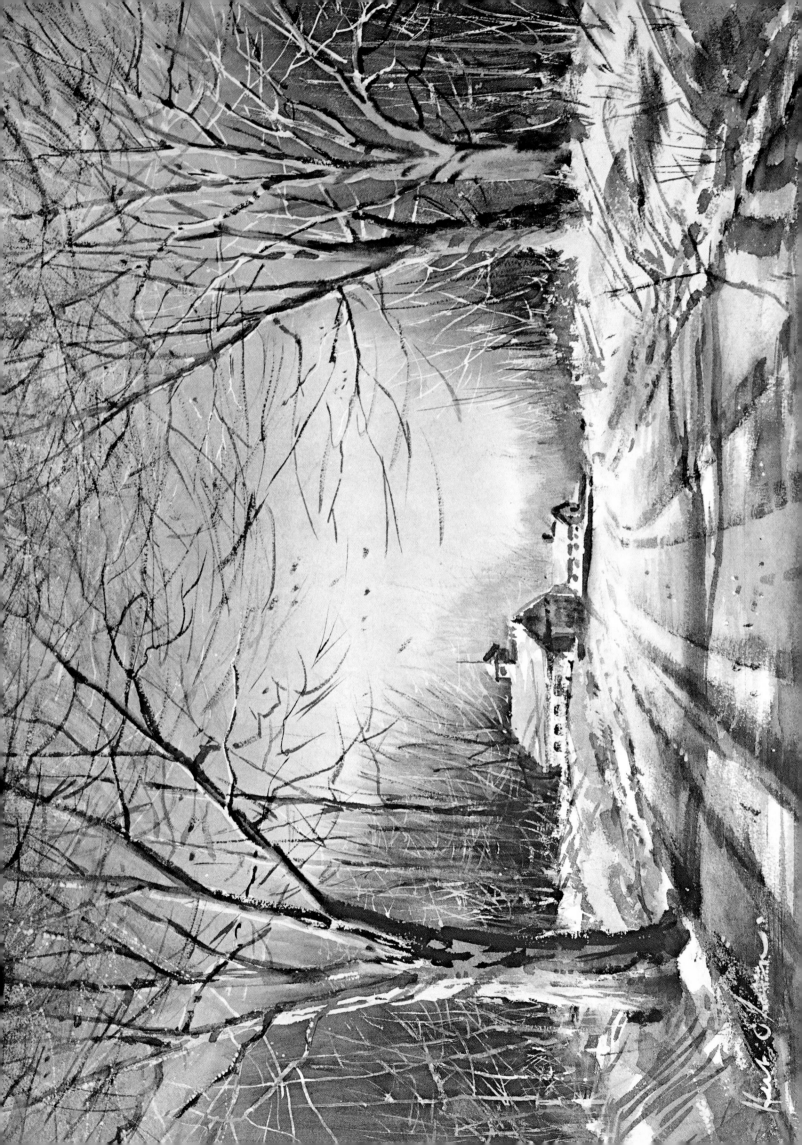

WINTER

A WINDING STREAM

A WINDING STREAM

In planning the composition for A WINDING STREAM I made the rough sketch shown below. While studying the sketch before starting the large drawing, the possibility of changing the road into a stream occurred to me. I felt a stream was very well adapted to the rest of the composition and that it would make the picture more interesting. Notice that, strictly speaking, the compositions are identical with the exception of the two large trees falling over the water in the final painting.

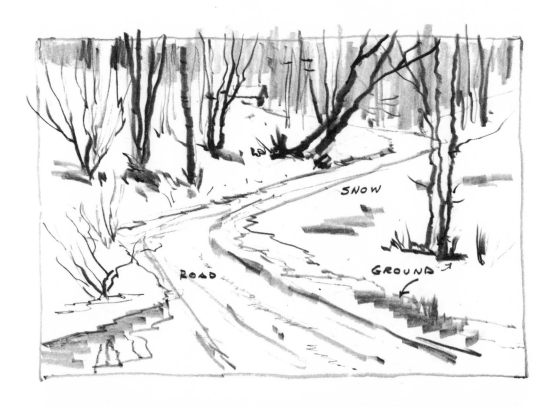

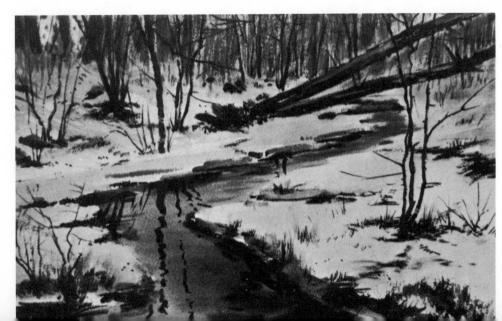

X. INVENTING THE SCENE

Finding subject matter to paint presents the artist with one of his biggest problems. It is not always easy to find an appealing, beautiful, or interesting scene made to order. But the practicing artist becomes so accustomed to thinking in terms of a picture that it is almost second nature for him to be on the lookout for one. I have learned to carry my camera with me much of the time, just in case I come upon a windfall. It is a habit I recommend highly.

During a recent vacation I discovered the theme for the painting SARASOTA BEACH. I was taking my usual stroll down the beach along with other shell hunters, looking for specimens to bring home and then throw away, when I happened to notice an interesting piece of driftwood. I picked it up with the idea of taking it home and adding it to my already large collection, when the old habit of seeing a picture began to take over. I placed the wood near a

clump of seaweed, added a few of my shells and a blowfish, and with my companionable camera took the snapshot from which the final painting was made.

You could not call this actually finding a picture, but rather inventing or making one. Strictly speaking, the composition is a still life, of course; yet it has the element of landscape, as it is a part of the beach. The moral to the story is this—if you can't find a composition, use your ingenuity and *make* one.

The following pages show how the painting was begun and developed, step-by-step. On page 53 are photographs I took at the beach. Page 54 shows two preliminary steps. The last step, showing the final painting in monochrome, is on page 57. The finished painting in full color is reproduced on page 56.

On page 57, you will also see another picture inspired by my stroll down the beach.

A SCULPTOR GETS AN IDEA FROM A PIECE OF DRIFTWOOD

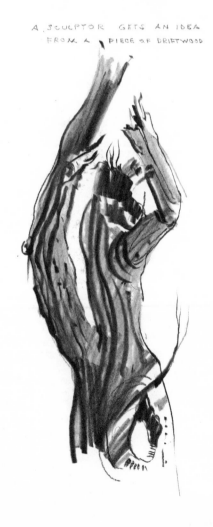

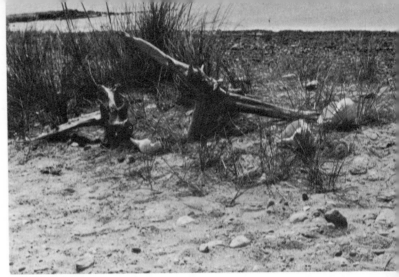

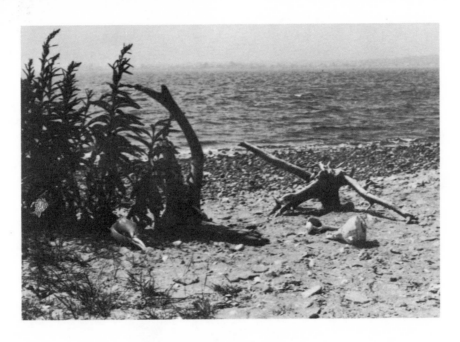

Driftwood in sculptural forms.

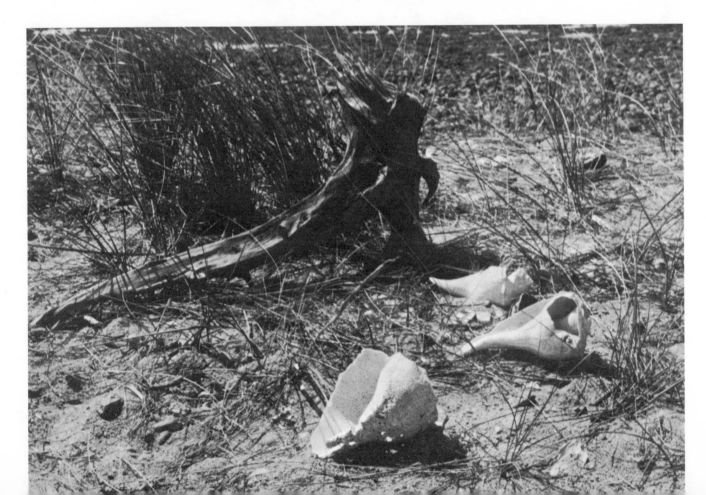

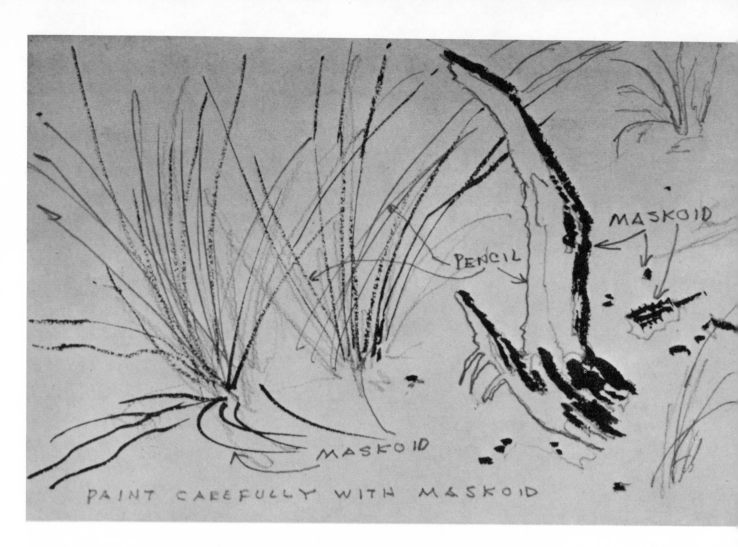

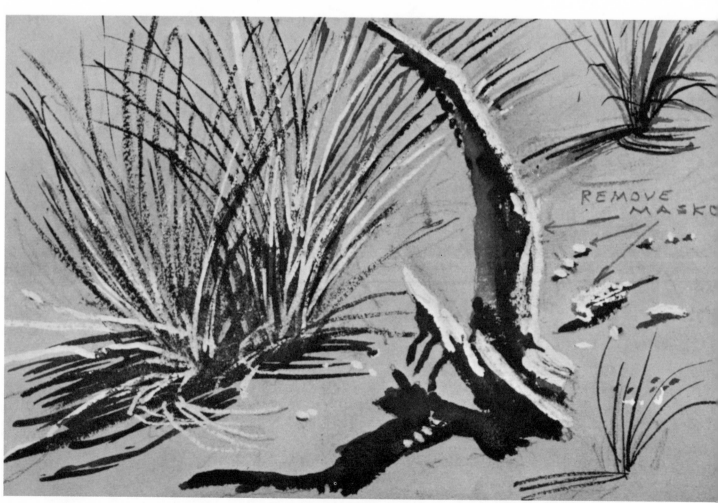

SARASOTA BEACH

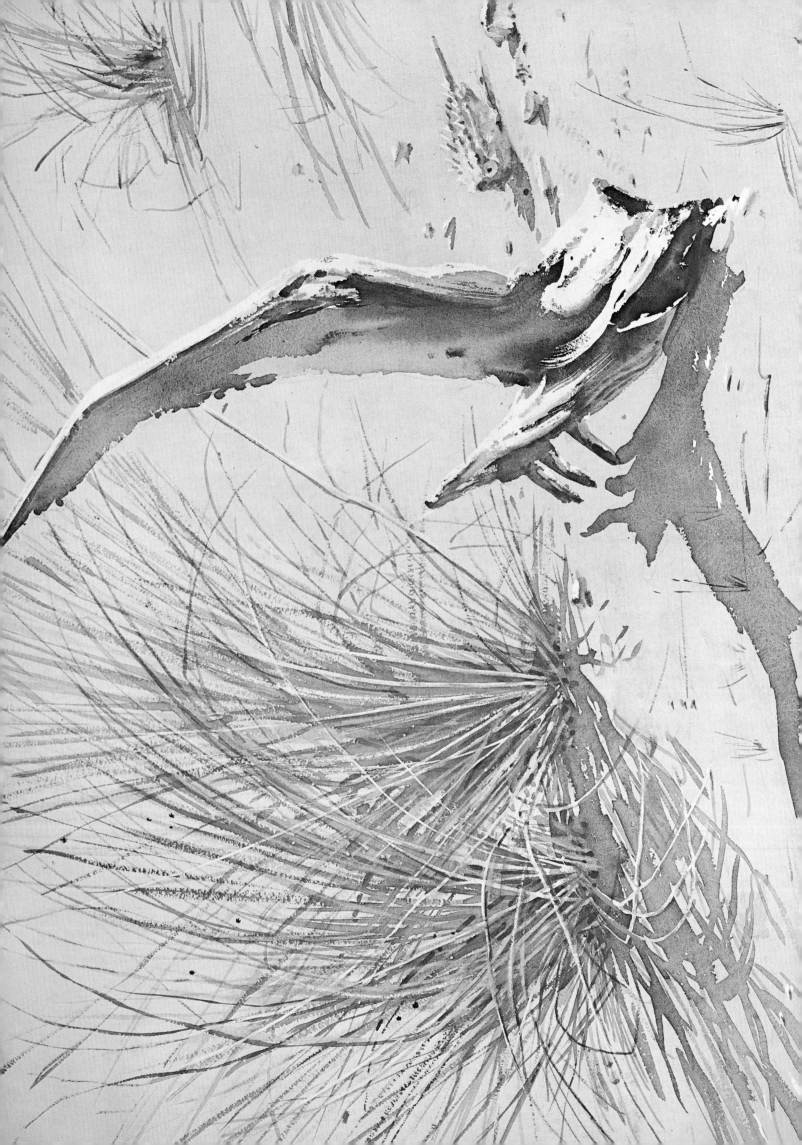

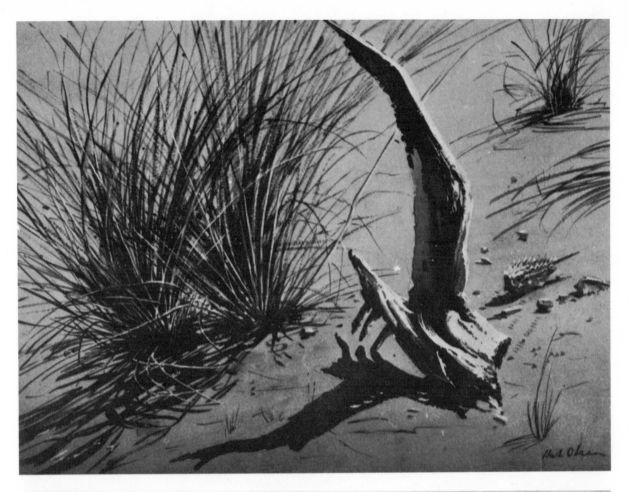

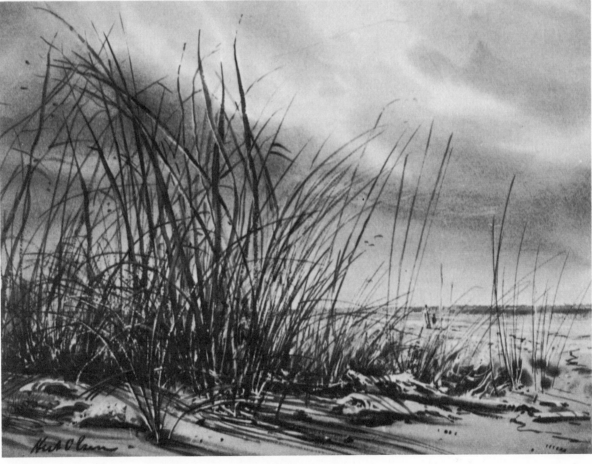

Here is another picture inspired by a stroll along Sarasota Beach.

57

XI. WATCH HILL

In an effort to combine, for demonstration purposes, as many of the elements of landscape as possible in this one painting, I think I was very fortunate in finding in my files the photograph shown opposite that I took many years ago in Watch Hill, Rhode Island. From it I made the Watch Hill painting. It is an example of how much help a photograph can be, but more than that it shows again how a scene can be changed and improved. My choice, first, was to raise the sky line, to avoid the look of a picture cut in half, and to increase the foreground to about two-thirds of the whole. Then I changed the fallen bulwark into a weatherbeaten log, added weeds, a puddle, and a few birds. This provided a pictorial means of demonstrating the painting of many of the component parts of landscapes illustrated in individual drawings throughout the book, such as rocks, stones, driftwood, weeds, grass, sand, and water.

The following materials were used to paint the finished picture reproduced in color on page 65.

PAPER: D'Arches, 300-pound
PENCIL: HB
BRUSHES: Aquarelle
Number 8
MASKOID
COLORS: Permanent Blue
Sepia
Yellow Ochre
Yellow Orange
Burnt Sienna
Antwerp Blue
Ivory Black
Cobalt Blue
Hooker's Green
Burnt Umber
Lemon Yellow

Step-by-step painting procedure for WATCH HILL begins on page 62.

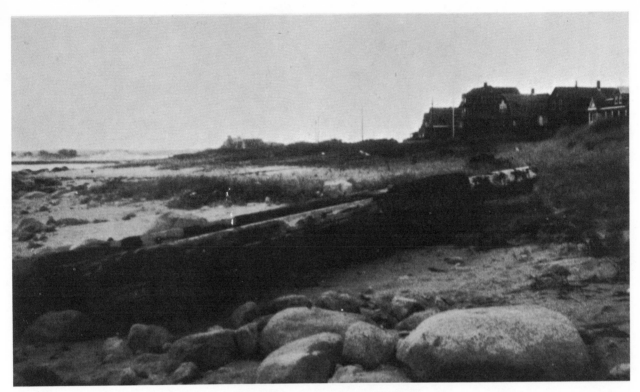

Photograph used for Watch Hill.

Final pencil sketch.

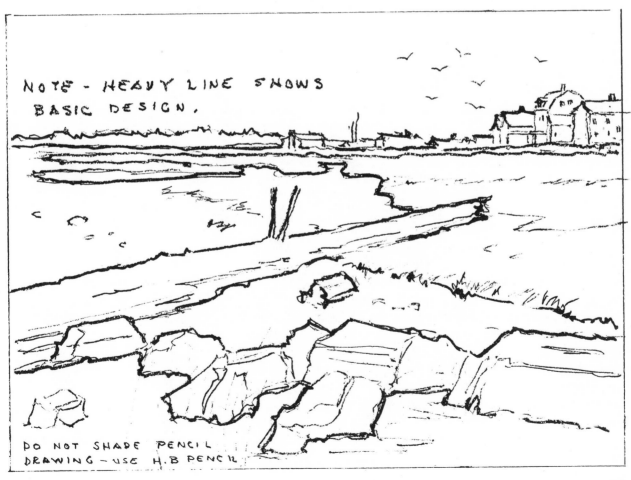

NOTE - HEAVY LINE SHOWS
BASIC DESIGN.

DO NOT SHADE PENCIL
DRAWING - USE H.B PENCIL

59

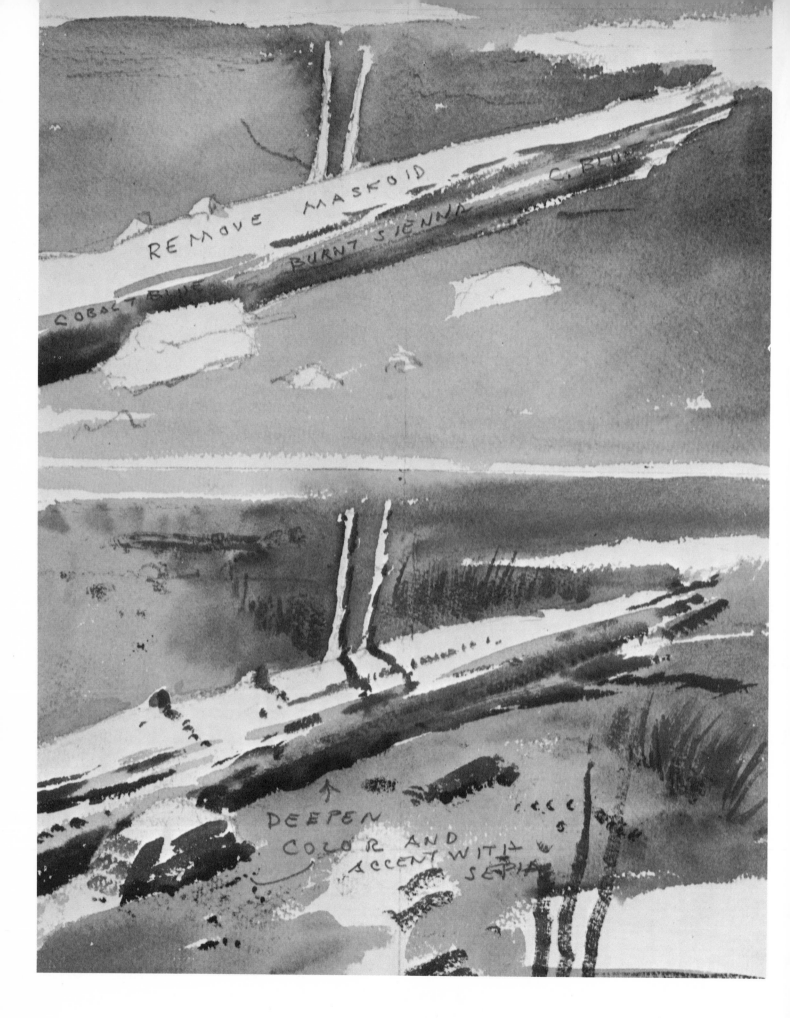

Painting driftwood.

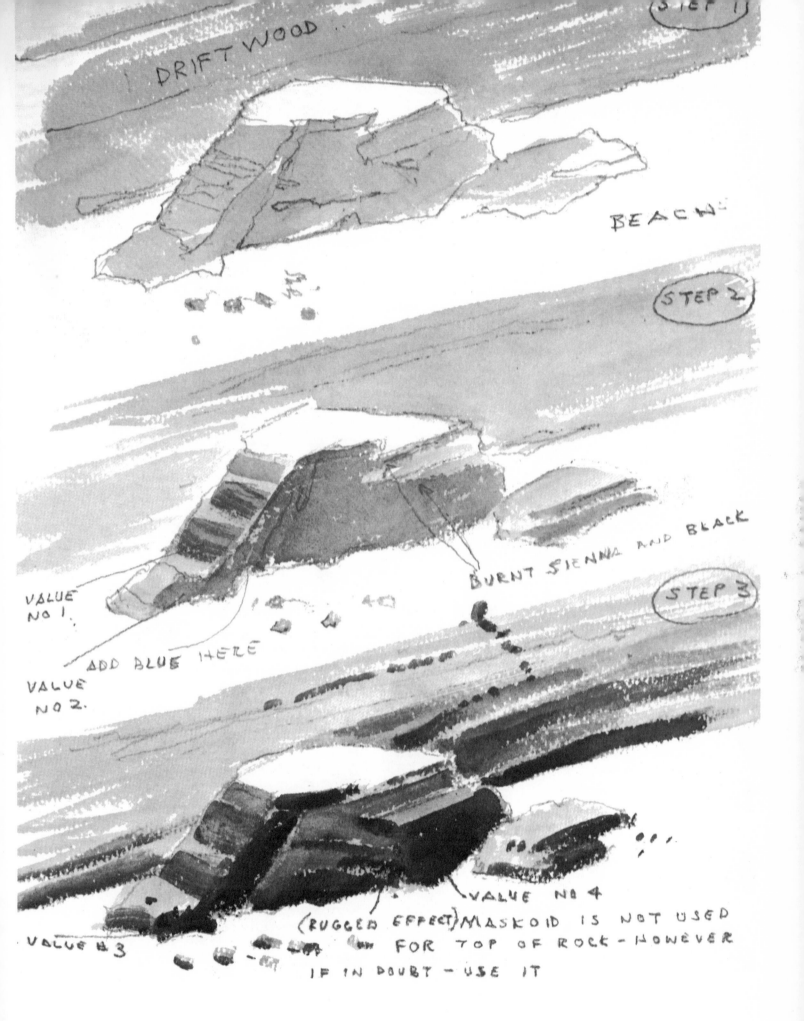

Painting a rock.

WATCH HILL

PAINTING PROCEDURE STEP-BY-STEP

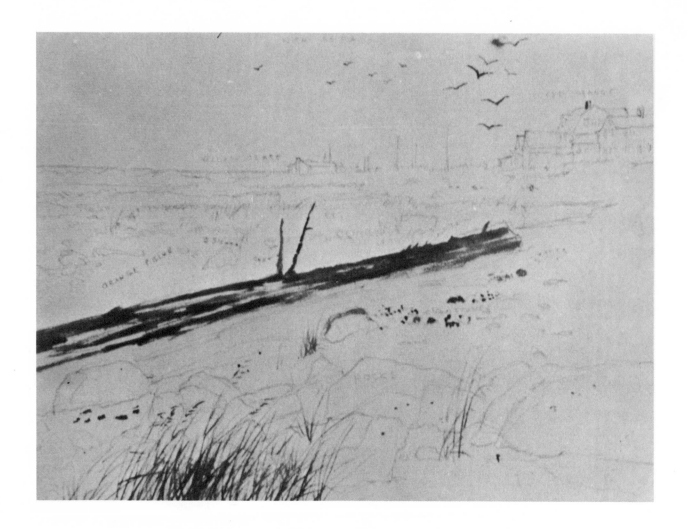

Step 1. A careful drawing made with an HB pencil, as shown on page 59.

Step 2. Above. Maskoid the driftwood, seaweed, a few small stones, and birds. When the Maskoid dries, sponge the sky with water. Then, while it is still wet, float on a wash of Permanent Blue and Sepia mixed on the paper. With a clean Aquarelle brush, continue painting toward the horizon line with horizontal strokes, using Yellow Ochre and Yellow Orange, letting the colors blend together.

Opposite:
Step 3. Using an Aquarelle brush, paint the entire foreground—with the exception of inlet water, rocks, log, and houses—with washes of Permanent Blue blending into Orange and Burnt Sienna.

Step 4. With a Number 8 brush, paint the buildings, using Burnt Sienna, Sepia, and Antwerp Blue, mixed on the paper. Paint the wooded area in the extreme background with Permanent Blue and Sepia, light. Then paint the rocks with Black, Burnt Sienna, Sepia, and Permanent Blue mixed on the paper. Let dry. Accent shadow side of the rocks with the same colors, intensified. Follow instructions for painting rocks on pages 61 and 67, for values.

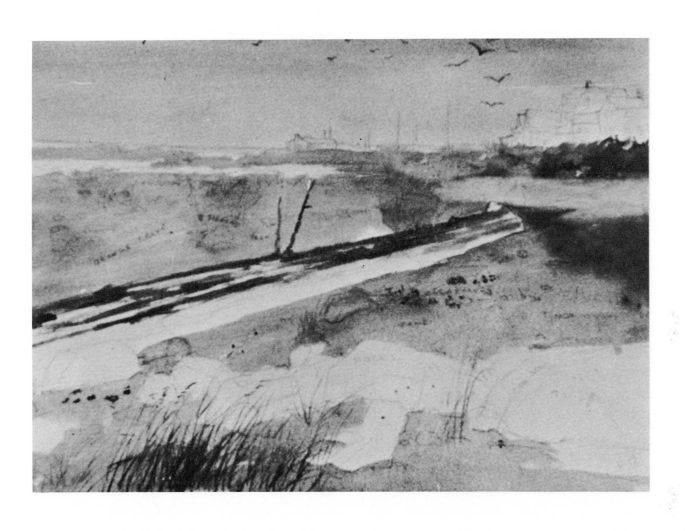

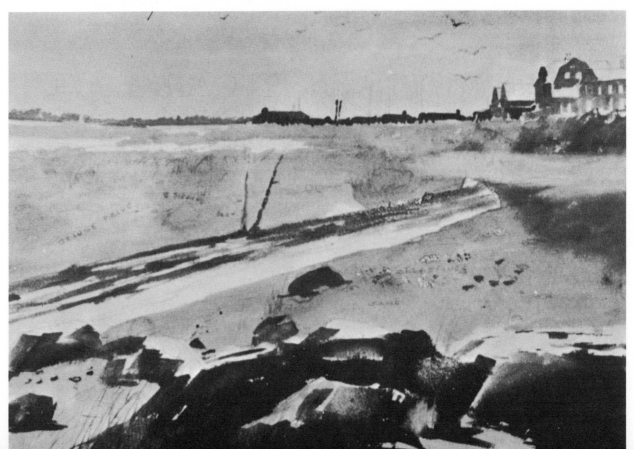

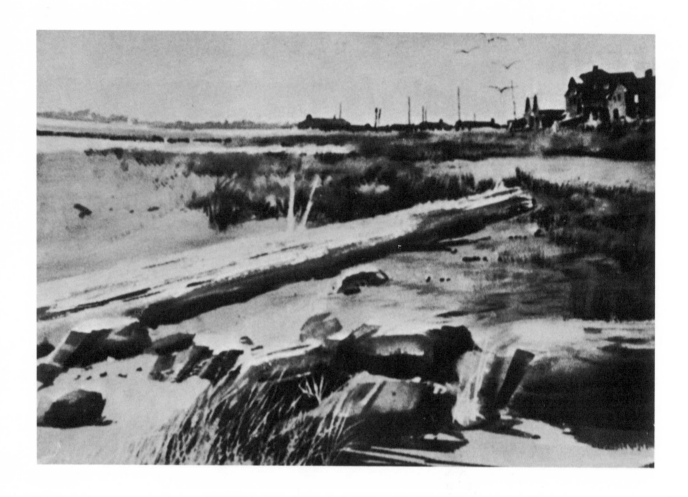

Step 5. Remove all Maskoid with a pickup. Paint gulls. For shadow on the wings, use Permanent Blue and Orange mixed on the palette, taking care to maintain whites. For the weather-beaten log, use Cobalt Blue and Burnt Sienna, floating the colors so that they meld together in the shadow area. Then reaccent the deeper shadow area using Sepia and Burnt Sienna, mixed on the paper, going into Permanent Blue as the shadow hits the sand. Paint grassy masses using Hooker's Green, Yellow Ochre, Burnt Sienna, and Burnt Umber, blending into each other. Instead of stroking on the color, use a stabbing or jabbing movement with the Aqua-relle brush—see page 10 for stroke demonstration. When the paper is dry, paint over the same area with the same colors intensified, leaving some of the lighter first wash to show through. Apply with the same jabbing strokes. For grass over the rocks in the foreground, glaze lightly with Lemon Yellow, rather dry. Roofs of the larger houses are Permanent Blue and Sepia, mixed on the paper. Paint the roofs on the smaller houses with a light wash of Cobalt Blue. Let dry. Paint the shadow areas of the houses with Burnt Sienna, Antwerp Blue, and Sepia—as in the original color of the houses, but deeper.

64

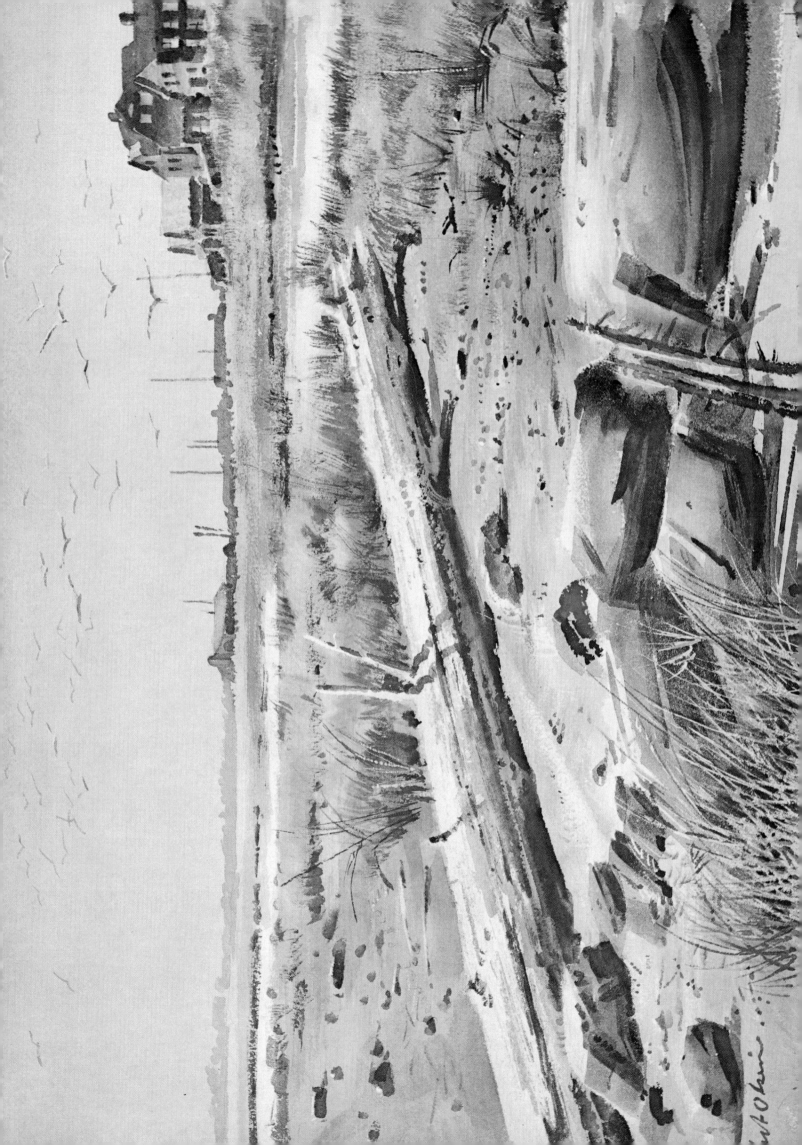

WATCH HILL

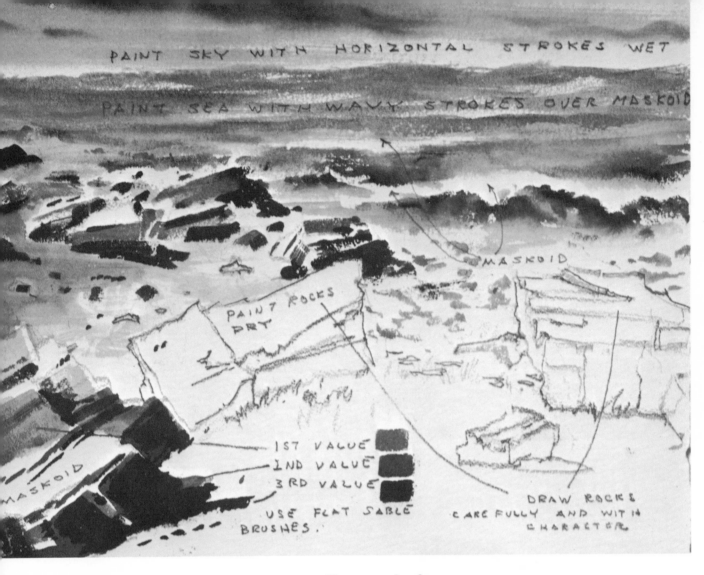

Sky, sea, and rocks.

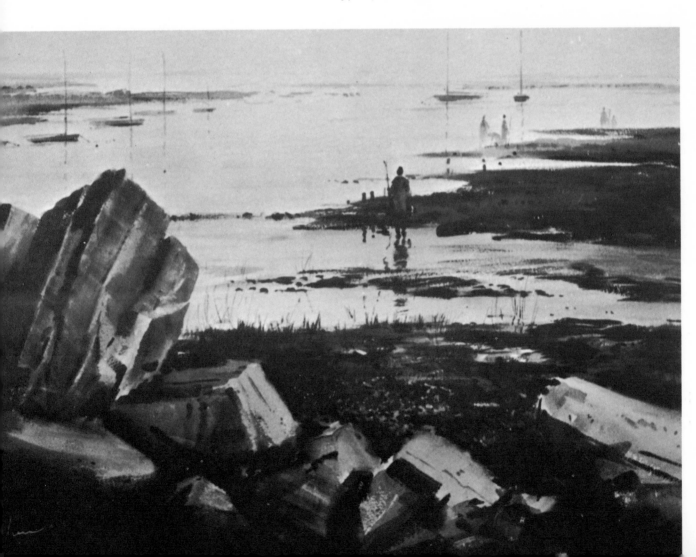

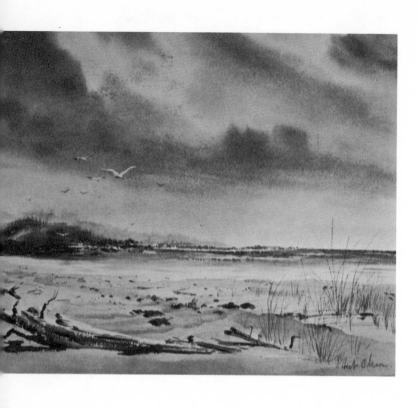

Seashore scenes.

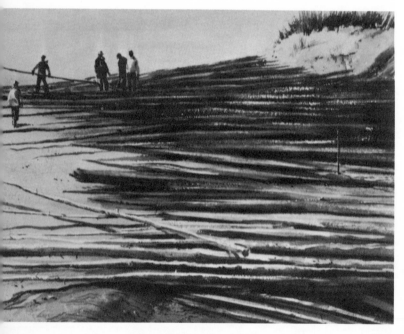

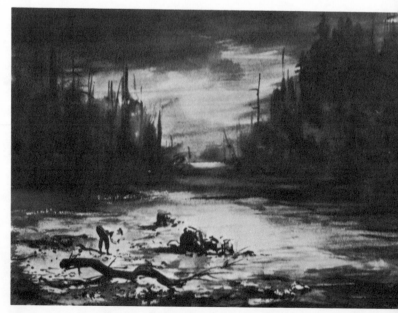

68

XII. AUTUMN CATHEDRAL

The very mention of the fall of the year immediately brings color to mind. Artists who live in the east where majestic maple trees add so much to the blaze find it particularly challenging to try to capture this beauty on paper. In my opinion the results are sometimes inclined to be a bit "corny," unless handled with restraint and taste. This I have tried to do.

Along our narrow New England country roads, the trees, their branches meeting, often form the effect of a vaulted arch and it is not difficult to imagine oneself in an edifice with stained-glass windows overhead. The autumn landscape I have painted was such a scene and it suggested to me the addition of the two nuns to enhance the aura of the AUTUMN CATHEDRAL. This painting is reproduced in color on page 76. The materials used are listed here.

PAPER: D'Arches, 300-pound

PENCIL: HB

BRUSHES: Aquarelle
 Numbers 2 and 8

MASKOID

COLORS: Yellow Ochre
 Lemon Yellow
 Burnt Sienna
 Cadmium Yellow Middle
 Cadmium Yellow Orange
 Cadmium Red
 Orange
 Burnt Umber
 Hooker's Green
 Sepia
 Indian Red
 Permanent Blue
 Mauve
 Ivory Black

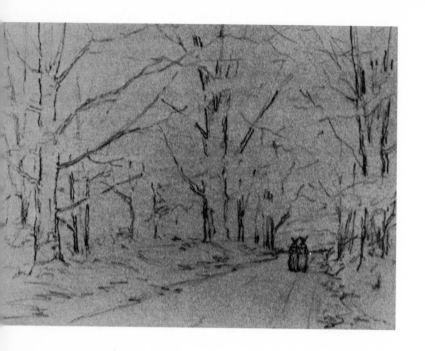

AUTUMN CATHEDRAL
PAINTING PROCEDURE
STEP-BY-STEP

Steps 1A and 1B. After making a carefully planned drawing (1A), paint patches of sky with Cobalt Blue, using the Aquarelle brush. Apply Maskoid to the white hats on the figures (1B) below.

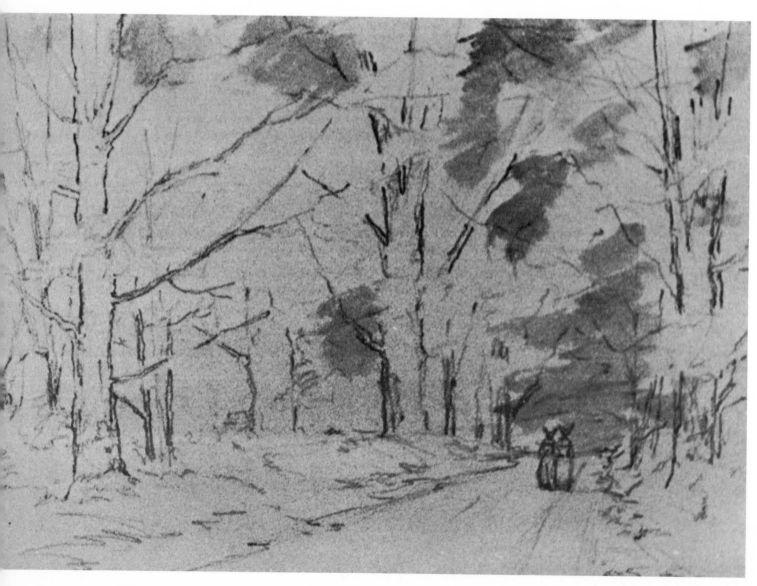

Step 2A. For the vivid fall foliage use a 2-inch brush. Paint freely and at random. Put down dabs of Yellow Ochre, Lemon Yellow, Burnt Sienna, Cadmium Yellow Middle, Cadmium Yellow Orange, Cadmium Red, Orange, Burnt Umber, Hooker's Green, Sepia, and Indian Red. These dabs are not mixed, on the paper or on the palette; instead, they should be allowed to run together. Paint the mountains in the background, using Permanent Blue and a touch of Mauve mixed on the palette. When dry, add darker notes of Burnt Sienna to the foliage at the top left-hand corner and on the lower portion of the tree on the right. Let dry.

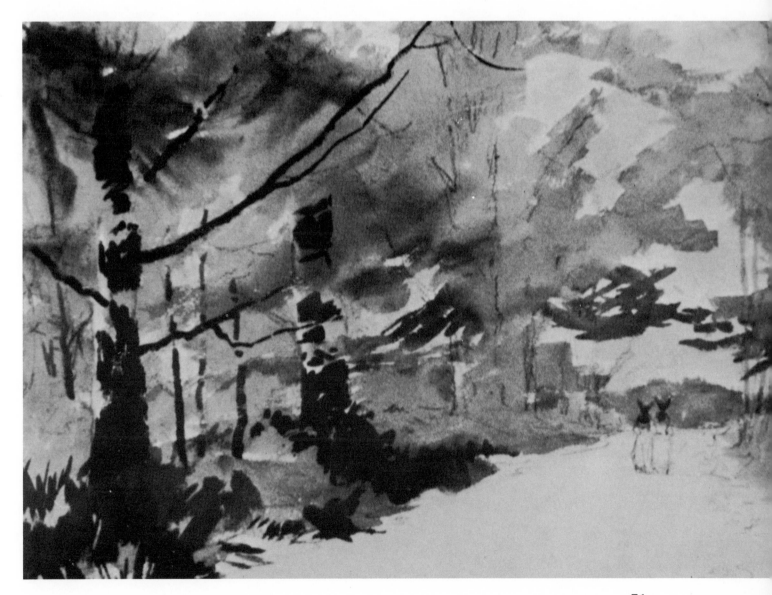

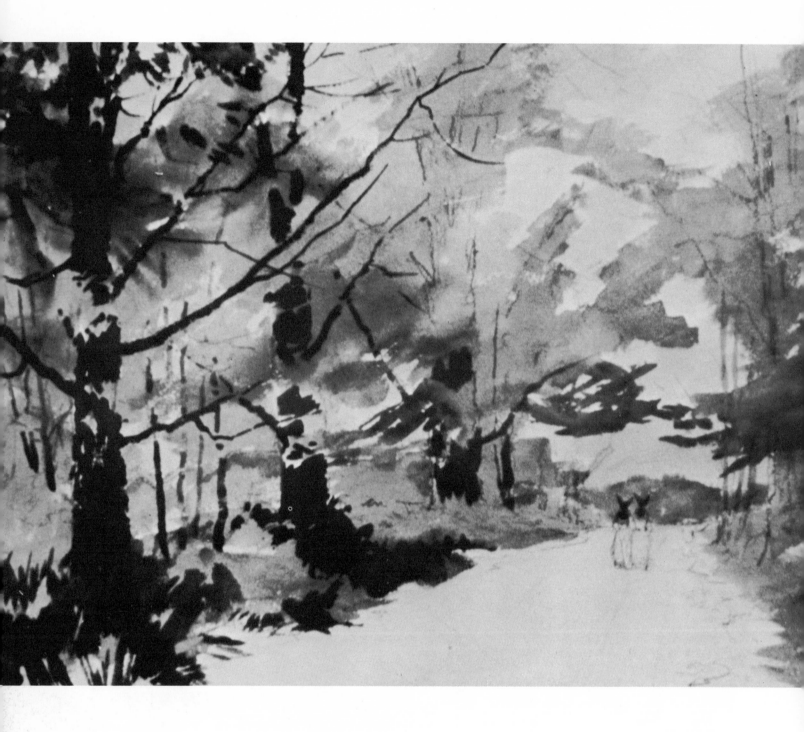

Step 2B. Use the Aquarelle brush for large tree trunks and the Number 8 brush for smaller limbs. Paint quite dry, using Sepia, Indian Red, and Hooker's Green mixed on the paper. For the weeds in the left corner foreground use Hooker's Green and Burnt Sienna, mixed on the palette, and Sepia and Orange for darker notes.

Step 3. With the Aquarelle, add Burnt Sienna to leafy portion of the tree on the area above the figures. Paint small trees in the background with Burnt Sienna and Hooker's Green. To the trunks of trees, continue adding the same colors as in Step 2B.

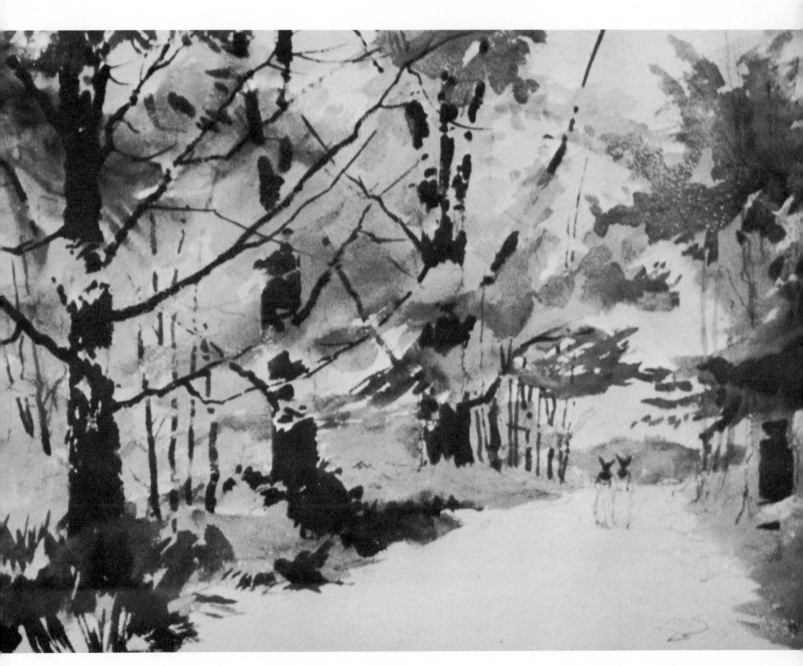

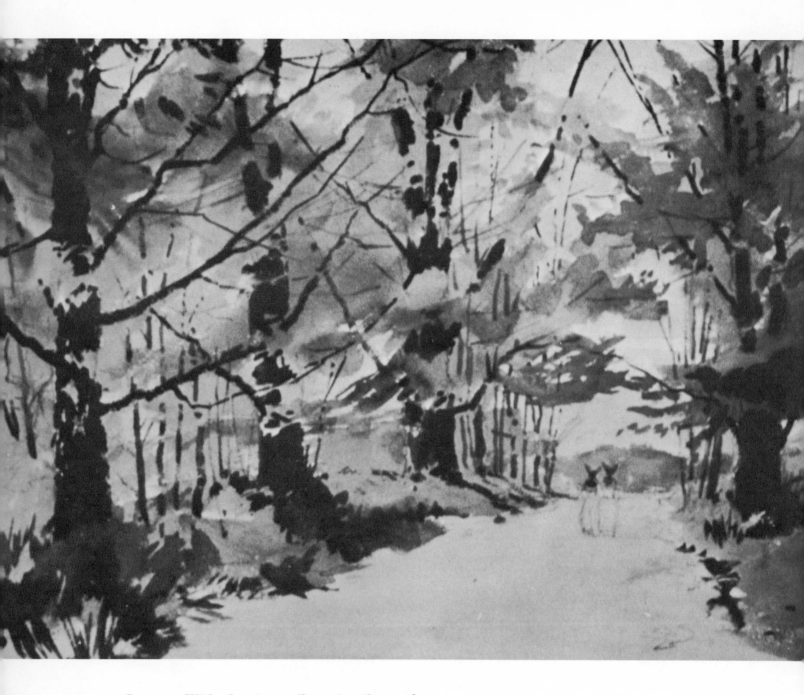

Step 4. With the Aquarelle, paint the road with a light wash of Orange. Continue to add tree trunks and limbs, using the same colors as in Step 3, taking care not to paint the trunks right on top of the foliage like telephone poles but to let the color break through—look at the color reproduction on page 76. In following these steps, note that no one area is completed before another. They are worked together, much like a sculpture. The final step will be found on page 77.

AUTUMN CATHEDRAL

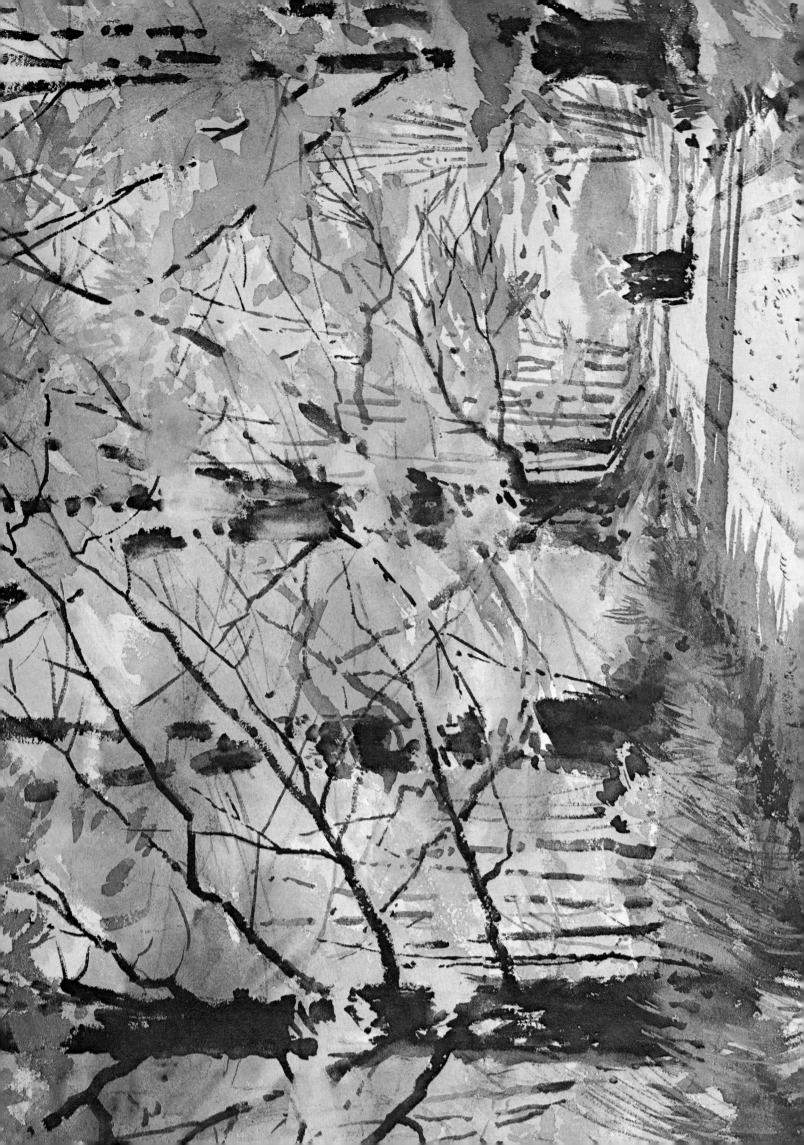

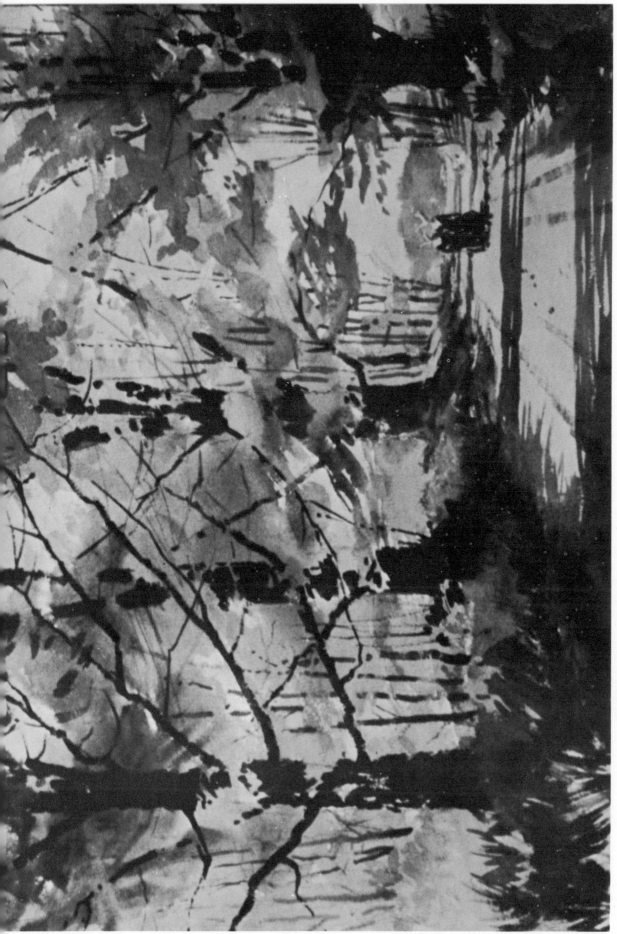

Step 5. With the Aquarelle brush, paint shadows across the road using Permanent Blue and Mauve with a touch of Sepia mixed on the palette, keeping the color on the blue side. Remove Maskoid from the hats on the figures. Using a Number 8 brush, paint the garments with Black and Permanent Blue mixed on the paper. Then add finishing touches to the road ruts, leaves, and stones.

XIII. CENTRAL PARK

In planning this painting, the rough sketches shown on page 79 were drawn on the spot. Notice how the large areas are blocked in abstractly in the first sketch, establishing the basis for the composition. Each step carries detail a little farther. Color notes were indicated in the final rough for future use. Then I photographed the scene for incidental data which was used in painting the picture in my studio.

On page 85 you will see the finished painting accompanied by another version without the rocks in the foreground. This certainly needs an explanation. When I had finished the first painting I asked my wife for her opinion. She said, "I think I would like it better without the rocks." I agreed, and proceeded to wash them out. I took a clean sponge and tepid water and started to lift out the surface color very carefully. Continuing, always with clean water and clean sponge, I accomplished the process of washing out the color in, I would say, about 12 separate operations. After each sponging the paper was blotted with an enamel-backed blotter (see pages 11 and 12). When only a trace of color remained, I washed the area with slightly warmer water and Ivory soap, then gave it a final rinse to remove the soap. All this is not too difficult to do, but it does require some courage and a lot of patience and, I stress, clean tools, water and sponge, for *each* application.

When the paper was thoroughly dry, the former rocky area was replaced with water, tree reflections, and grass, changing the picture immensely and, I think, improving it. It also serves to demonstrate again that, contrary to much misinformation about watercolor, deletions can be made and mistakes can be corrected.

The materials I used for this painting are given below.

PAPER: D'Arches, 300-pound
PENCIL: HB
BRUSHES: Aquarelle
 Numbers 5, 8, and 12
MASKOID
COLORS: Yellow Ochre
 Permanent Blue
 Lemon Yellow
 Ivory Black
 Orange
 Hooker's Green
 Burnt Sienna
 Sepia
 Antwerp Blue
 Burnt Umber
 Rembrandt Green

78

Preliminary sketches for Central Park.

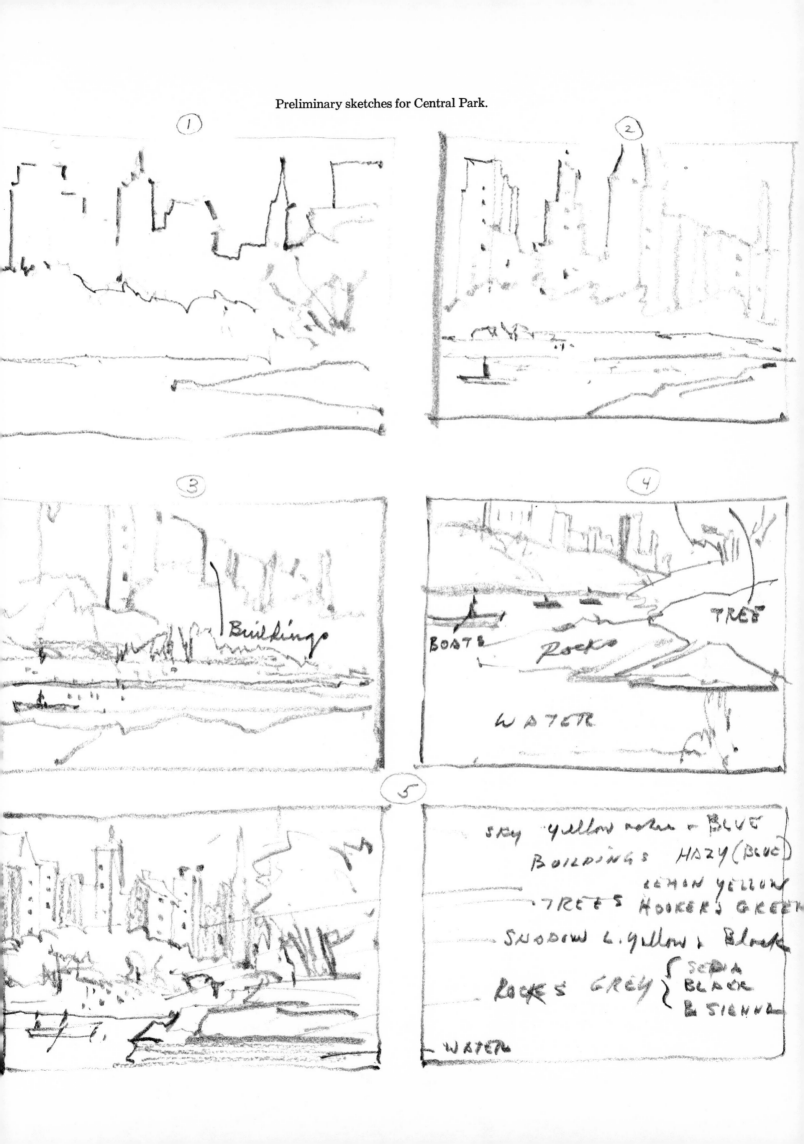

1

2

3

Buildings

4

BOATS Rocks TREE

WATER

5

SKY yellow ochre + BLUE
BUILDINGS HAZY (BLUE)
 LEMON YELLOW
TREES HOOKER'S GREEN
SNODOW L. yellow & Black
ROCKS GREY { SEPIA
 BLACK
 B. SIENNA

WATER

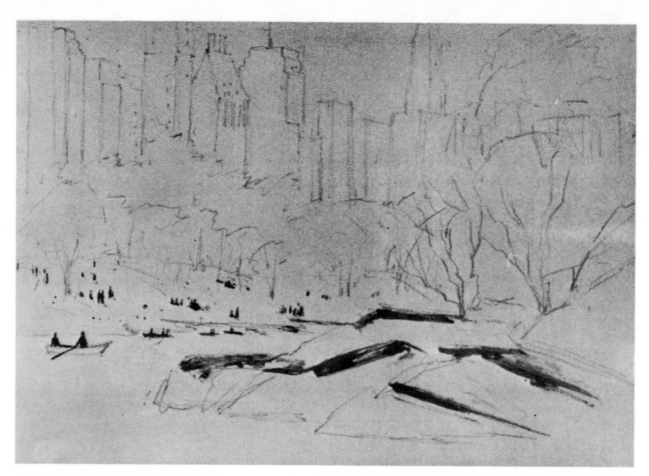

CENTRAL PARK

PAINTING PROCEDURE

STEP-BY-STEP

Step 1. With an HB pencil, complete the drawing. Then carefully paint Maskoid on the rocks and the figures.

Step 2. Sky and buildings. First sponge the paper with clear water to remove any grease or oil stains and to make a fluid effect possible. Be careful not to get the paper too wet. Then, with the sponge, in horizontal strokes, immediately apply a light wash of Yellow Ochre and Permanent Blue mixed on the palette. Let dry.

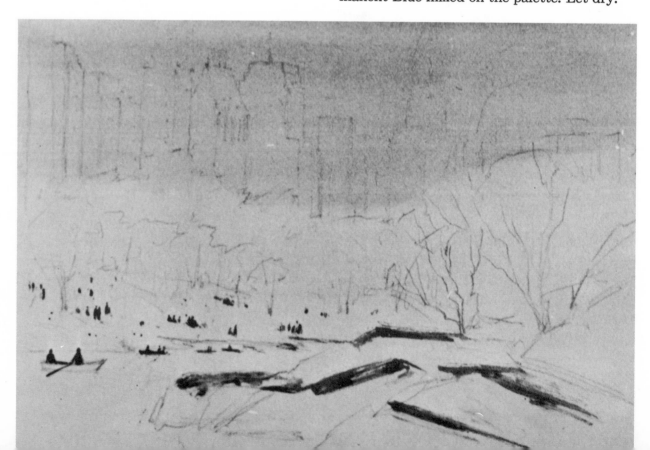

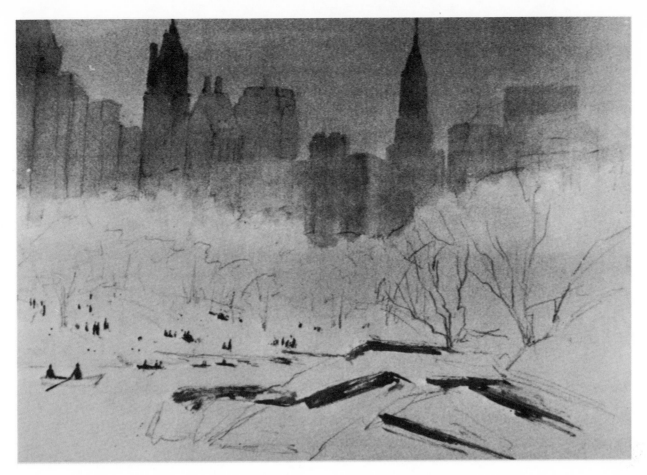

Step 3. Buildings. Using the Aquarelle brush, paint lightly with Yellow Ochre and a little Permanent Blue mixed on the paper. Use a Number 8 brush for smaller areas such as chimneys and spires. Let dry.

Step 4. Landscape area and trees in the center section of the painting. Use the Aquarelle brush and paint with a light wash of Lemon Yellow. Then, while still damp, use the same brush and add Black to Lemon Yellow, mixed on the palette, and apply accents of darks. Let dry. For the lighter bank area, use a sponge to apply a light wash of Orange, Hooker's Green, and Burnt Sienna, mixed on the paper.

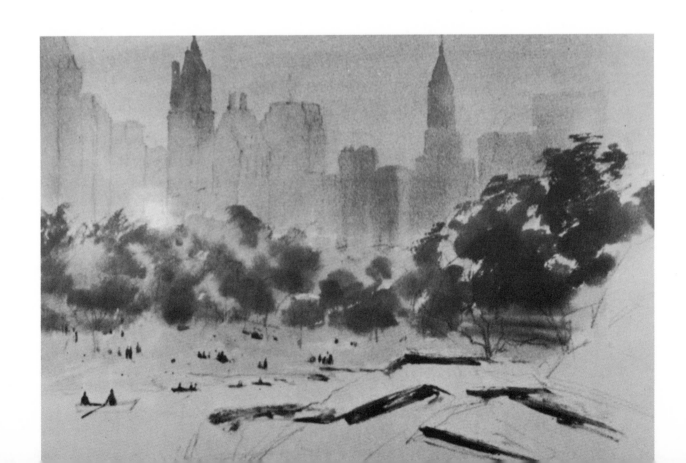

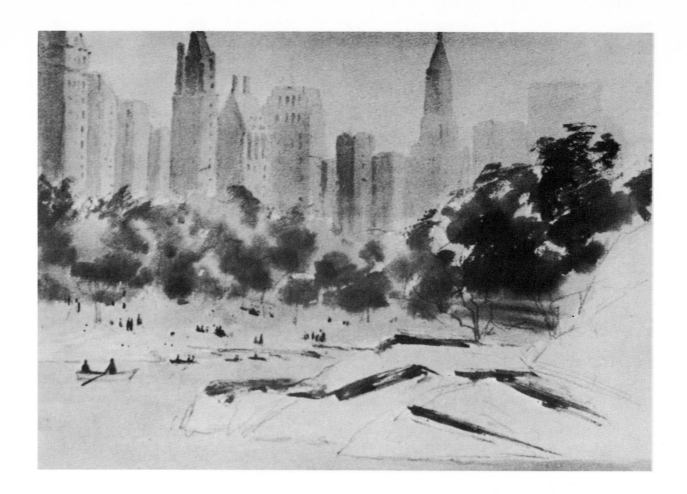

Step 5. Paint yellow sides of the buildings with the Aquarelle brush, using Yellow Ochre and Permanent Blue—not too wet. For windows use same colors and apply with a Number 5 brush.

Step 6. With a sponge, paint water in horizontal strokes, using sky colors of Yellow Ochre, and Permanent Blue mixed on the palette. Paint right over the boats and Maskoid figures. Add trunks to the trees in the background with a Number 8 brush, using Burnt Sienna and Sepia.

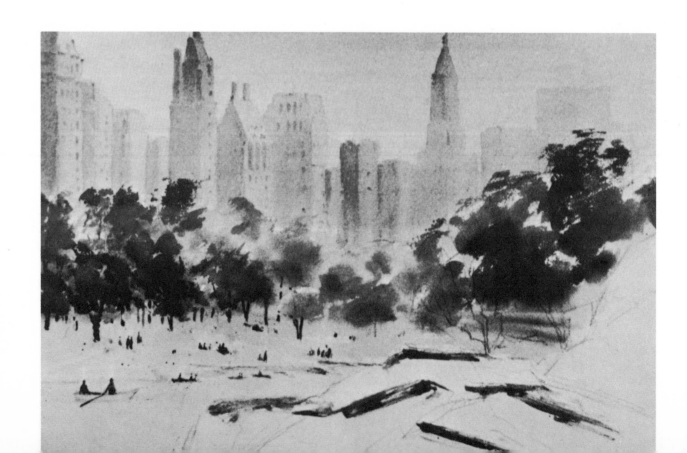

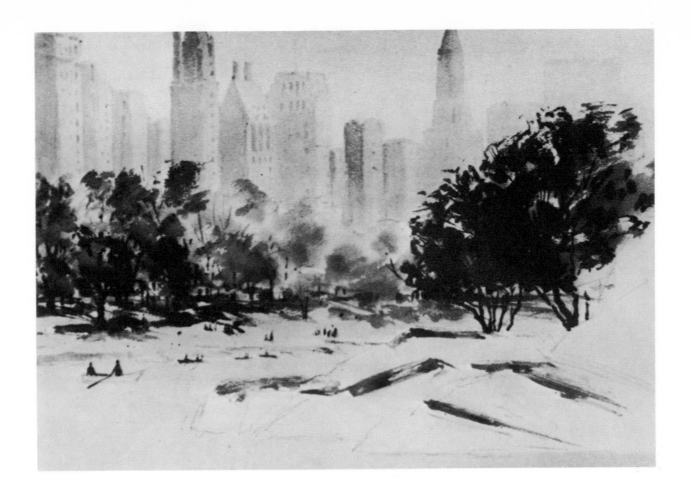

Step 7. For darker values in the trees, use Lemon Yellow and Black. Add more tree trunks and limbs as in Step 6. With the large round Number 12 brush add foliage to trees in the right foreground using Hooker's Green, Orange, and Sepia mixed on the paper. Add shadows under the trees in the background, using Lemon Yellow and Black mixed on the palette.

Step 8. Paint the rocks with the Aquarelle brush, using the following colors mixed on the paper: Burnt Sienna, Sepia, Permanent Blue, Antwerp Blue, Burnt Umber, and Black. Follow the Color Plate to see how colors fall at random.

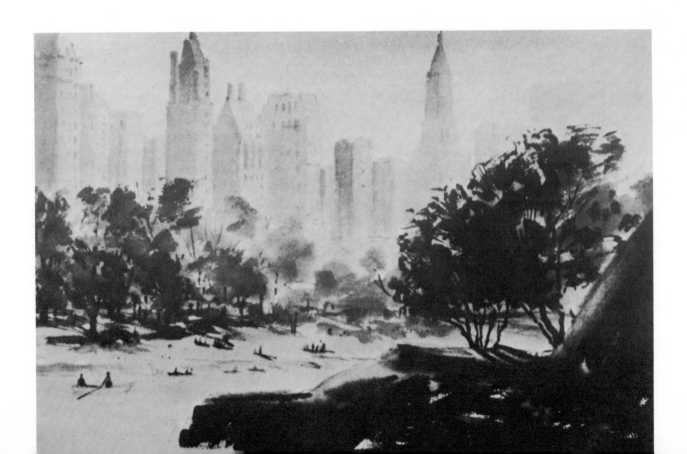

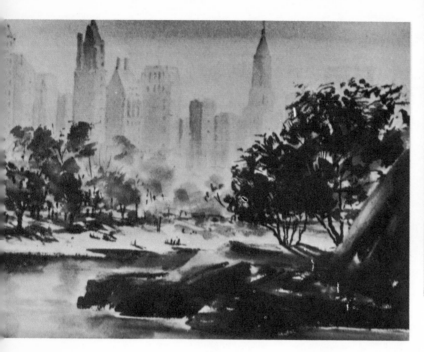

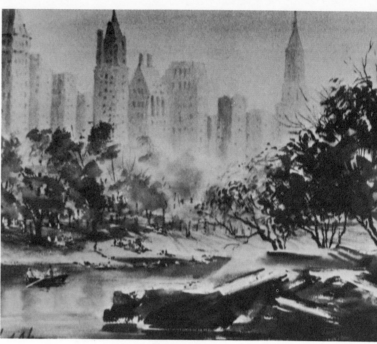

Step 9. For faint reflections of buildings in the water use Lemon Yellow and Hooker's Green and apply in light vertical strokes.

Step 10. When the paint is thoroughly dry, remove the Maskoid. For reflections of rocks in the foreground apply Rembrandt Green and Yellow Ochre in horizontal strokes, with a sponge. For the figures on the bank and in the boat follow the Color Plate.

After this, the rocks were deleted. The procedure is fully explained on page 78.

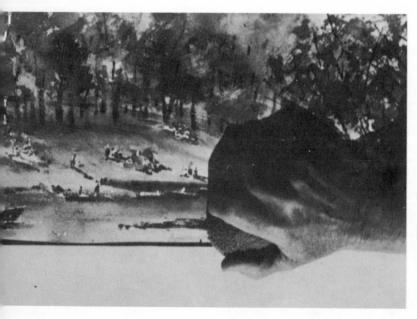

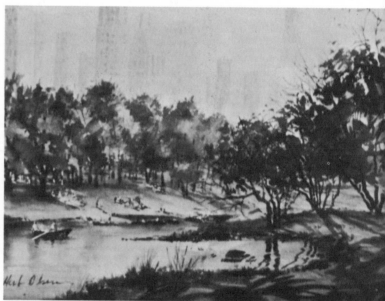

Rocks are removed with a sponge. Former rock area is repainted.

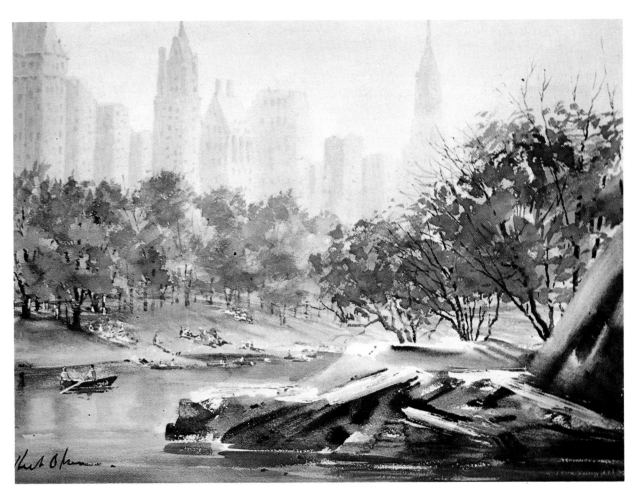

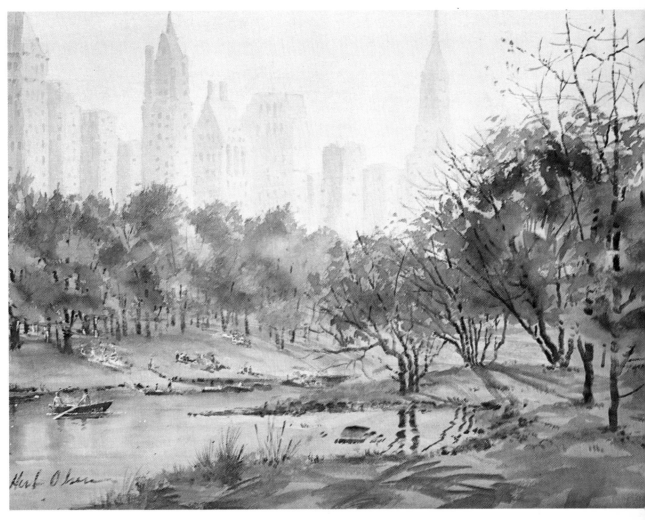

CENTRAL PARK

BEFORE REMOVING ROCKS

CENTRAL PARK

AFTER REMOVING ROCKS

86

XIV. CLOUDS

A cloud is a large visible mass of fog or haze floating in the atmosphere. Clouds are classified technically into three broad divisions: the cirrus, a feathery cloud of great altitude; the stratus, or layer cloud; and the cumulus, a solidly packed, dome-shaped cloud of comparatively low altitude. Each classification has many subdivisions. But for painting purposes there are, roughly, two large classifications of clouds —those seen on a wet, stormy, or threatening day, and those seen on a dry, clear, sunny day. Each category includes an infinite variety.

"Wet" clouds are not really painted but are the accidental result of dropping color from the brush onto the paper and then immediately tilting the paper so that the color runs down, forming the effect desired. The exact opposite is true in painting the clouds seen on a dry, clear, sunny day—these are very carefully planned.

To achieve the rain sky shown on page 89, the sky area was first sponged with a very wet sponge. Then, while the paper was wet, a light wash of Yellow Ochre was applied at the base, blending into Permanent Blue at the top. Then, still while the paper was very wet, heavy splotches of Sepia, Permanent Blue, and a touch of Burnt Sienna were dropped from the Aquarelle brush across a strip at the top of the sky. Leaving a space in between, another strip of the same colors was dropped in the same manner across the paper. Then the paper was immediately tilted into a top to bottom vertical position for just a moment until the color had run into the formation desired, and then immediately placed in a horizontal position to dry.

This is the general approach to painting rain skies. The variety of shapes and effects comes about by applying color either in strips or splotches and then tilting the paper. For a stormy or windswept sky such as APPROACHING STORM (page 90) or in STORM OVER KANSAS (page 96), the paint for the clouds was dropped on the paper in a more irregular pattern than that on page 89, and the paper was tilted sideways to allow the paint to run into the windswept effect.

Clouds seen on a dry, clear, sunny day are achieved in an entirely different way. Actually they are not painted at all. The sky is painted, and their shadows are painted but the clouds themselves are the unpainted areas of the paper left without color. Sometimes a cloud is washed out of a painted sky with a sponge. The bristle brush or the sponge should always be used to soften the edges in order to avoid that much-to-be-abhorred pasted-in look or cut-out look; this, of course, is done after the paper has dried.

In the case of both wet and dry clouds the soft, feathery quality, without hard edges, must always be kept in mind.

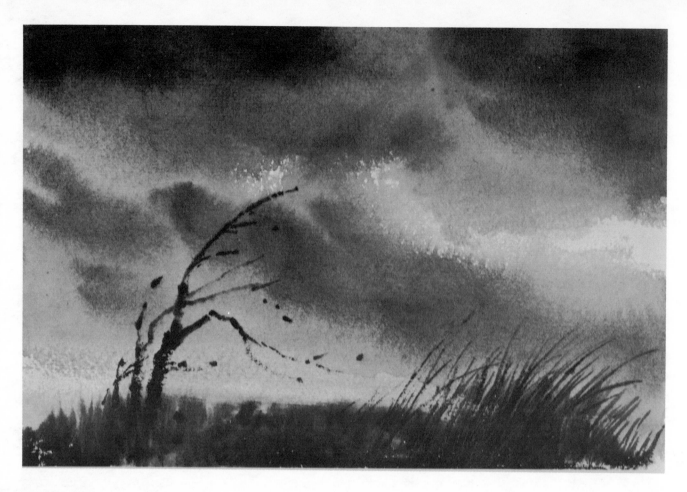

Windswept sky.

Sunny with clouds.

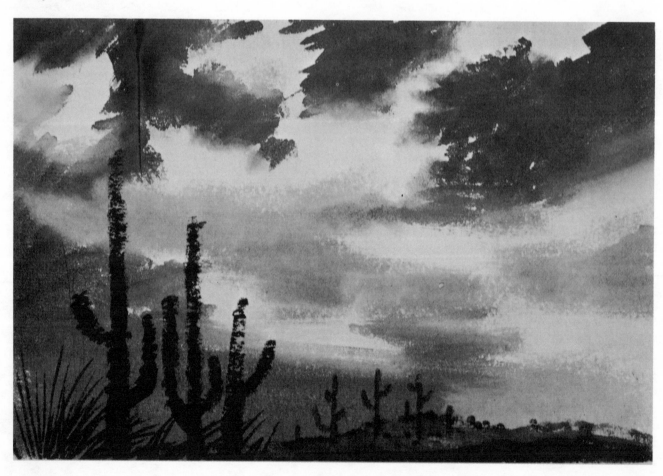

88

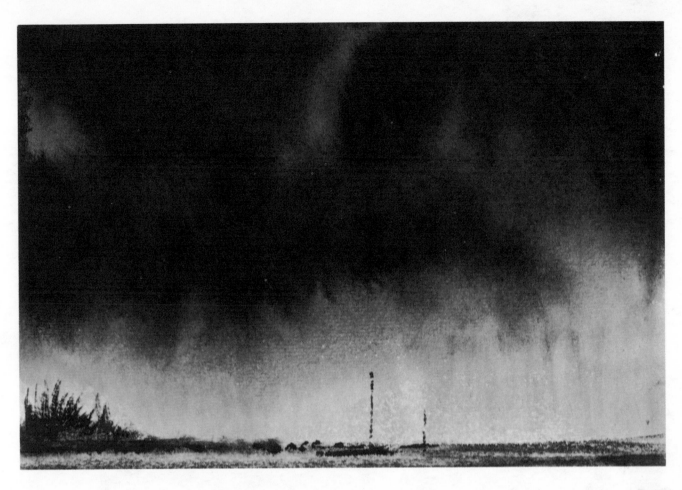

Rain.

End of day.

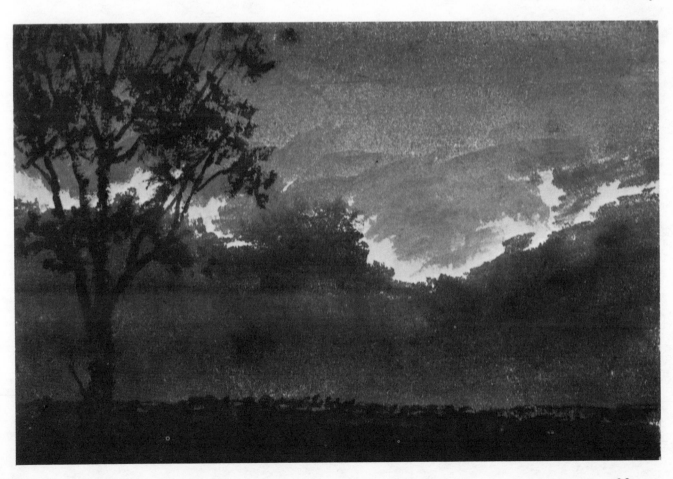

Storm clouds.

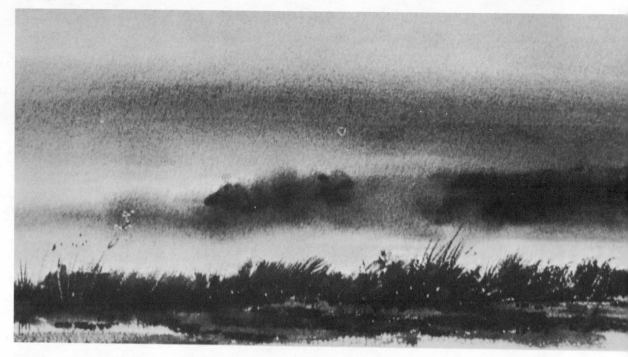

Approaching Storm. Shown in color on page 2.

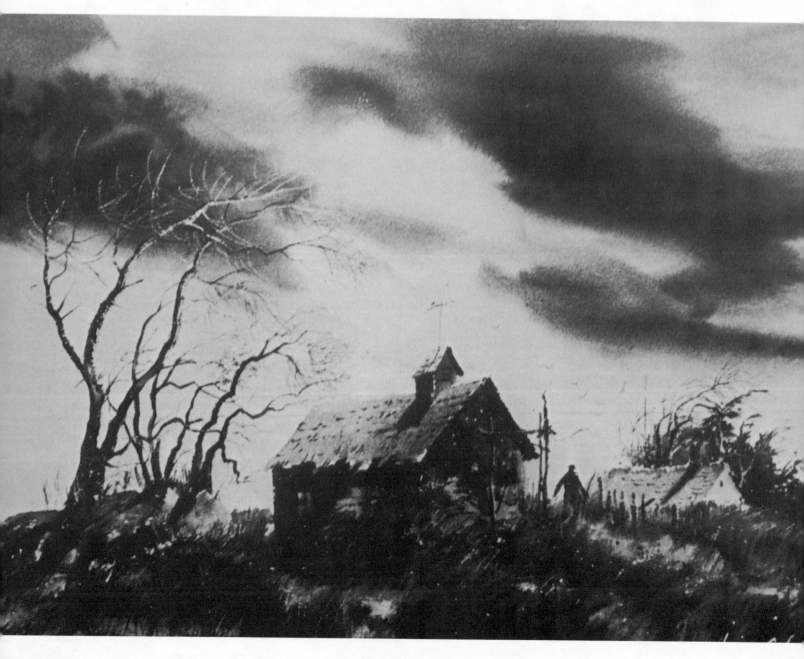

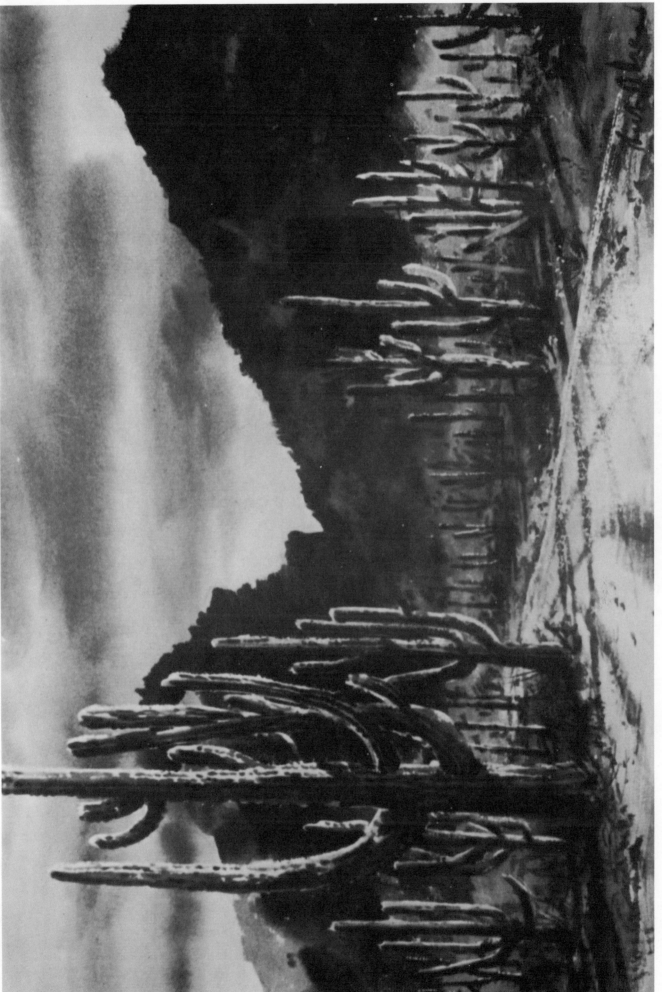

Arizona sky.

Here are two steps in painting Storm Over Kansas, shown in color on page 96. Note the changes in the composition.

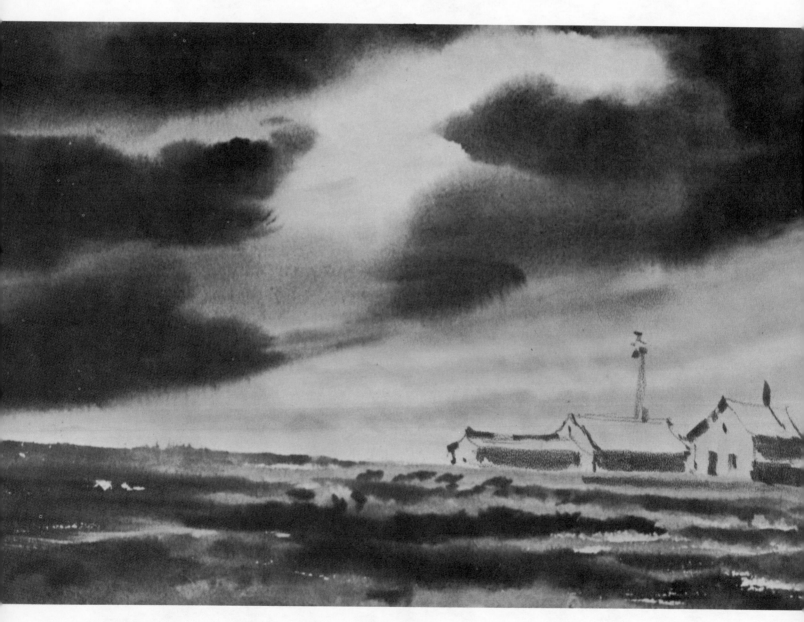

92

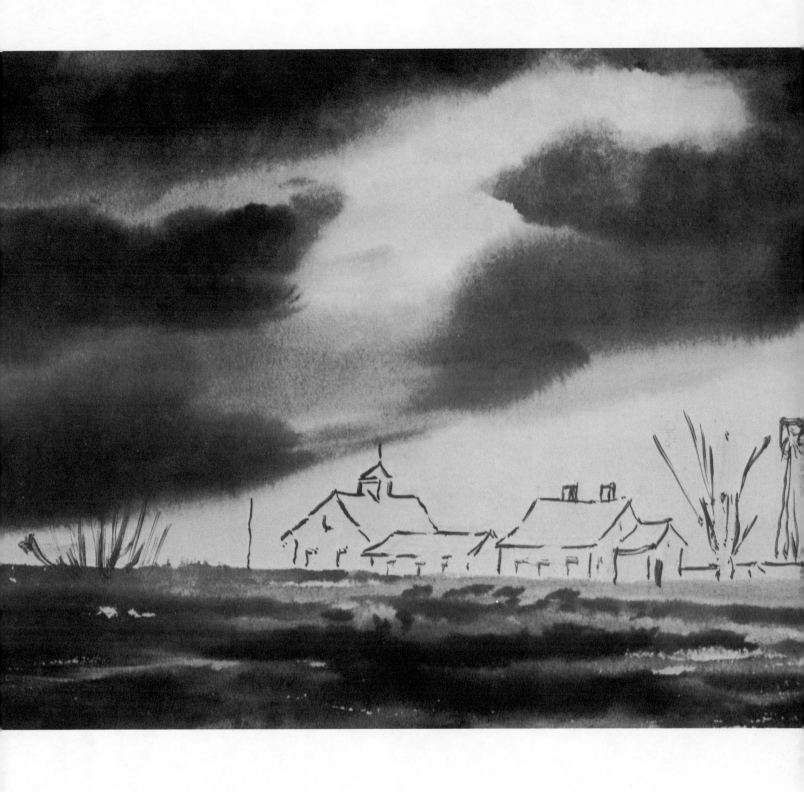

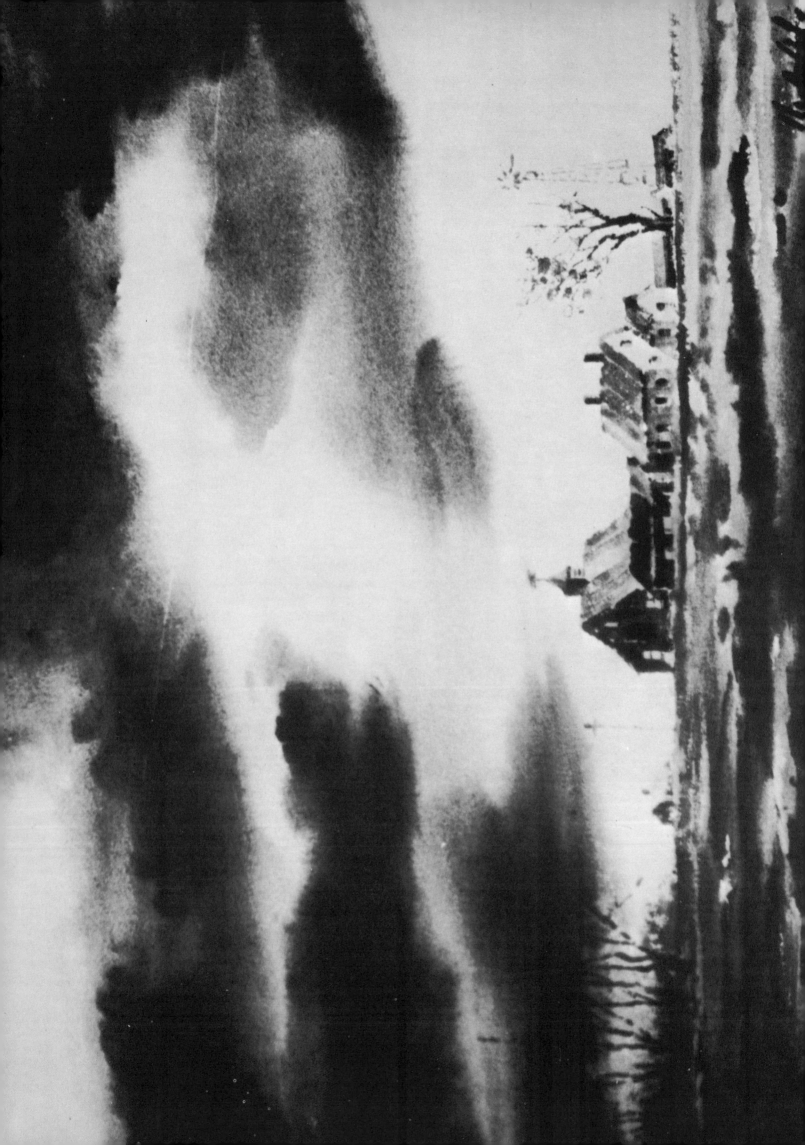

STORM OVER KANSAS

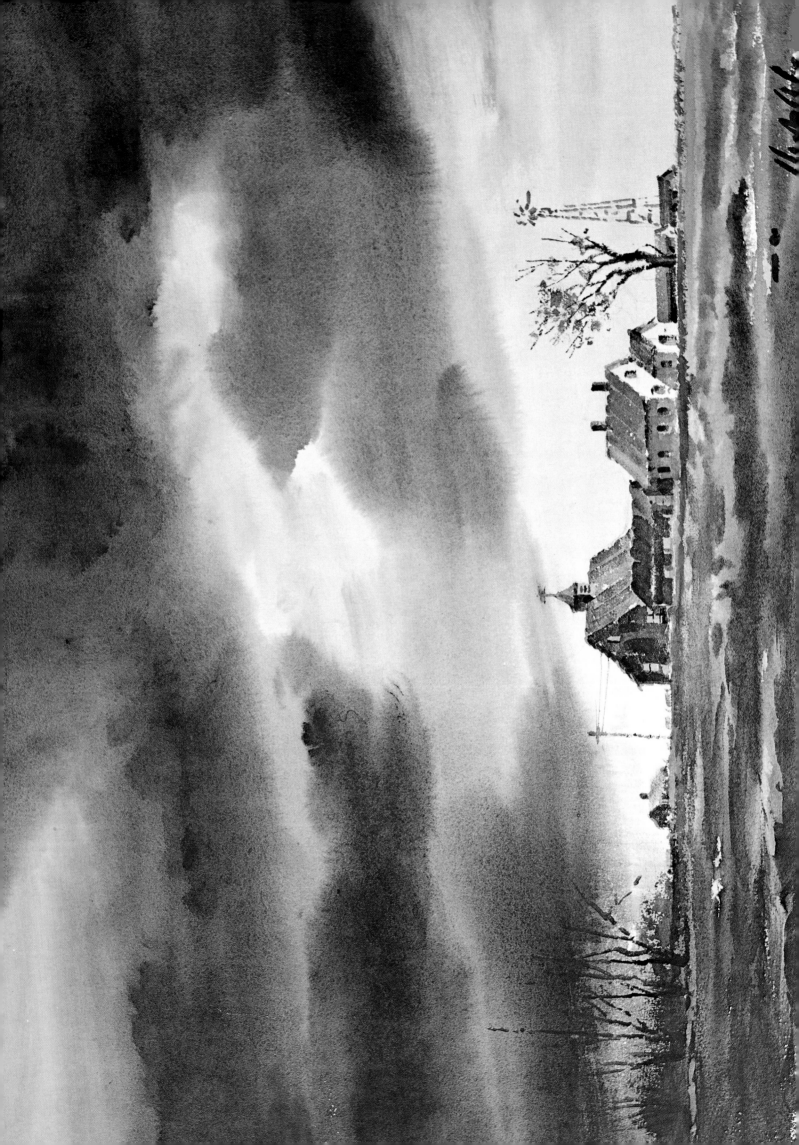

XV. A DESERTED CABIN

Strangely enough, at least to my way of thinking, beautiful people, or magnificent buildings, or well-cared-for landscapes seldom make interesting subject matter for paintings. Although lovely to look at, in most cases they lack the qualities of mystery and character that the artist strives to incorporate into his picture.

In my own early career I was so attracted to dilapidated, broken-down shacks that a dealer once asked me, "Olsen, can't you just once paint a not-so-broken-down shack?" "I can't find any that interest me enough to paint," I answered.

The fascination still continues, and I think A Deserted Cabin, shown on page 105, has the required elements of mystery and character. It leaves much to the imagination. Who lived here? What kind of a life could he or she have had in this isolated spot? What kind of a person was the inhabitant? As you can see in the photographs of the first four steps, I had originally planned to include a figure. As the painting progressed I began to feel that the figure detracted not only from the composition but also from the feeling of desertion. I feel that by eliminating it I came much closer to the mood I was trying to capture. The absence of all life—human as well as natural—is further emphasized by the dormant straggly sycamores and the

dead grass. The empty rocking chair speaks poignantly of life departed.

Several alternative titles for this painting suggested themselves, such as the song titles "And the Old Man Died" or "Annie Doesn't Live Here Anymore." However, both of these titles focus interest on the rocking chair. Therefore, for the purposes of the lessons involved in painting the cabin and the sycamores, I chose the more prosaic title of A Deserted Cabin. However, in the future, if the painting is intended for exhibition rather than for instruction, I may ultimately retitle it autobiographically "The Old Rocking Chair's Got Me."

The materials I used in painting this picture are given below.

PAPER:	D'Arches, 300-pound
PENCIL:	HB
BRUSHES:	Aquarelle
	Number 8
MASKOID	
COLORS:	Yellow Ochre
	Permanent Blue
	Antwerp Blue
	Middle Yellow
	Lemon Yellow
	Burnt Umber
	Sepia
	Burnt Sienna
	Hooker's Green

A DESERTED CABIN

PAINTING PROCEDURE STEP-BY-STEP

Step 1. After making a careful drawing, apply
Maskoid to the sycamore trees and the rocking
chair. Let dry.

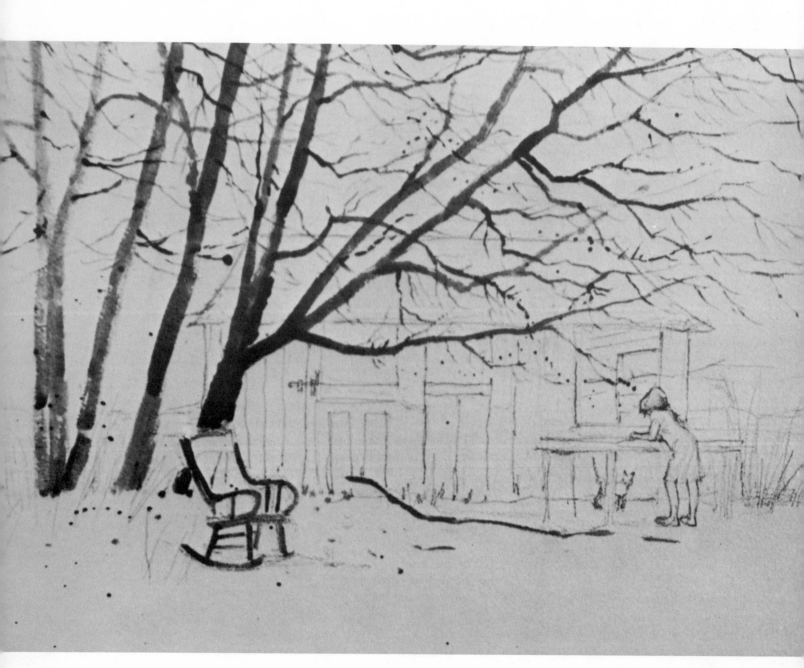

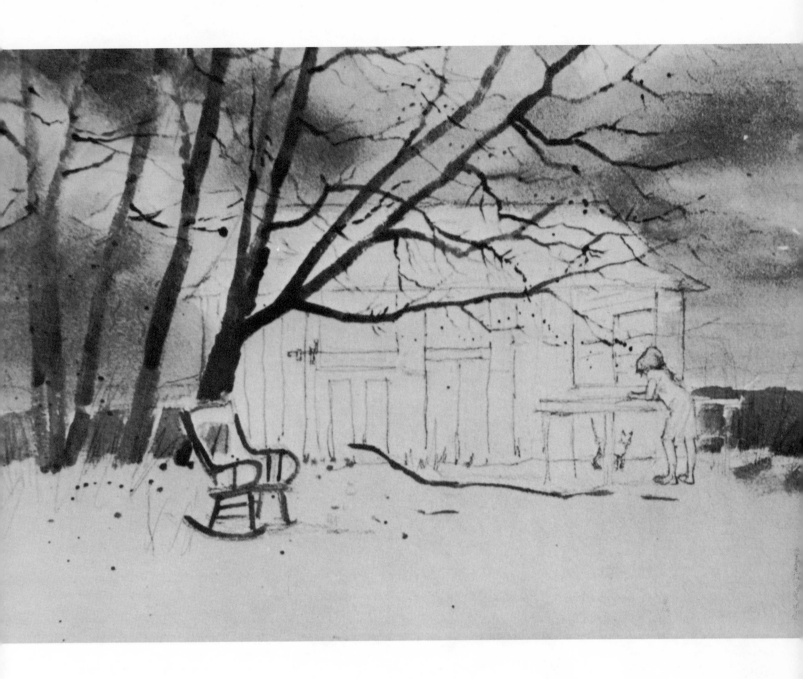

Step 2. Sponge the sky with clean water. While wet, paint sky color over the dried Maskoid with the Aquarelle brush, using Yellow Ochre, Permanent Blue, and Antwerp Blue, mixed on the paper. Leave pattern of clouds without color.

Step 3. Also with the Aquarelle brush, paint all the ground with Middle Yellow, Permanent Blue, Lemon Yellow, Burnt Umber, Sepia, Burnt Sienna, and a touch of Hooker's Green, blended on the paper. Paint the mountains in the background with Permanent Blue, light.

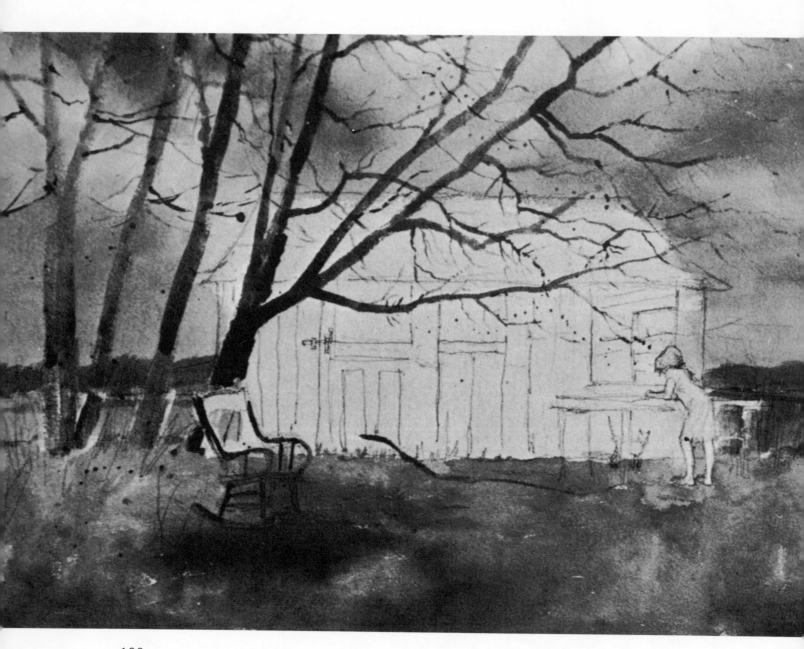

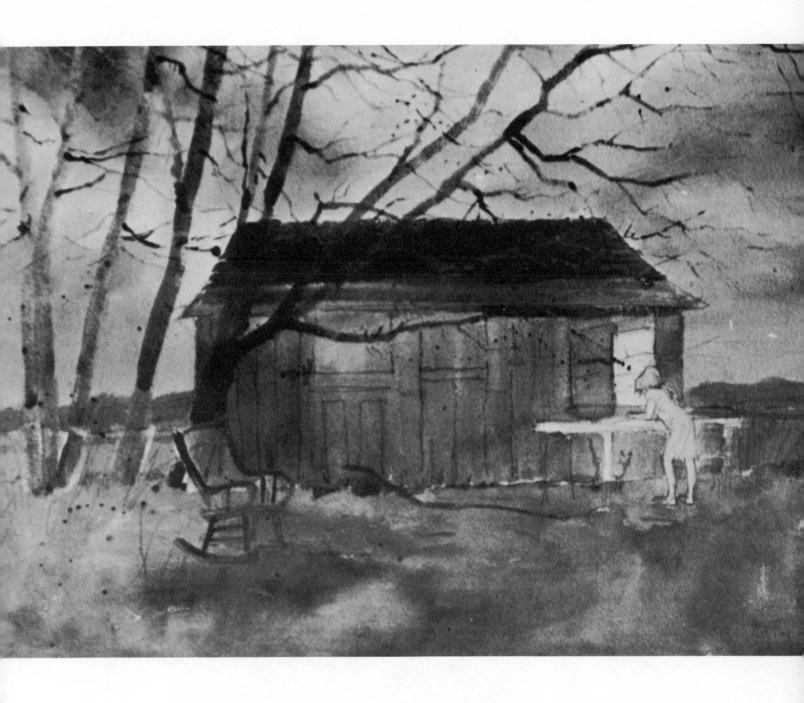

Step 4. Continue painting with the Aquarelle brush. Paint the cabin with Hooker's Green, Middle Yellow, Permanent Blue, Antwerp Blue, and Burnt Sienna, blended on the paper. Apply a light wash of Middle Yellow on the entire roof of the cabin. While still wet, paint the darker upper portion of the roof with Permanent Blue, Antwerp Blue, and Sepia, blended on the paper. Paint *over* Maskoid, not around it. Note that the figure was eliminated after this step (see page 97).

Step 5. Paint shadows diagonally on the cabin with the Aquarelle, using Permanent Blue and Burnt Sienna, mixed on the palette. Allow light underpainting to show through—follow the Color Plate on page 105. Paint the dark grassy area at the base of the sycamores in foreground of the cabin and at right side with Hooker's Green, Burnt Sienna, Sepia, and Yellow Ochre, blended on the paper. Paint rather dark. When thoroughly dry remove all Maskoid.

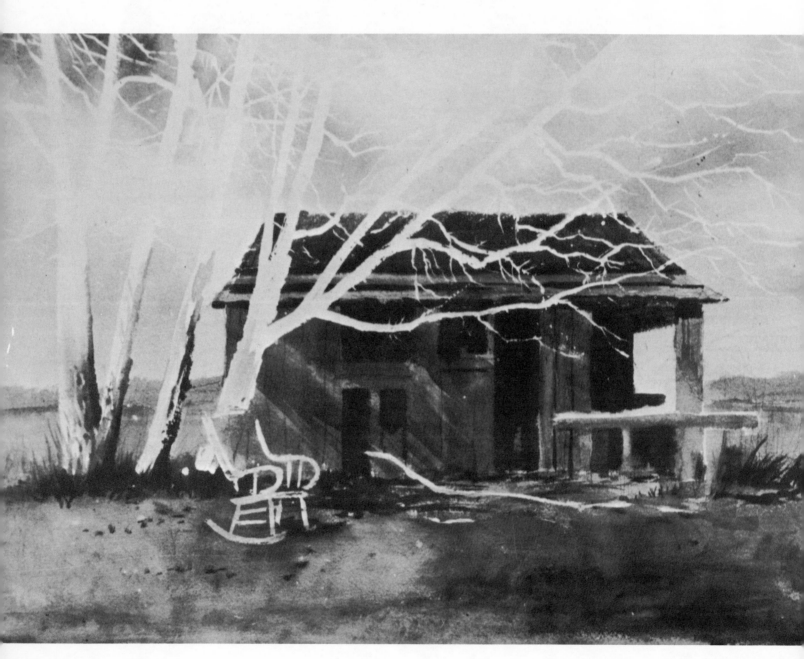

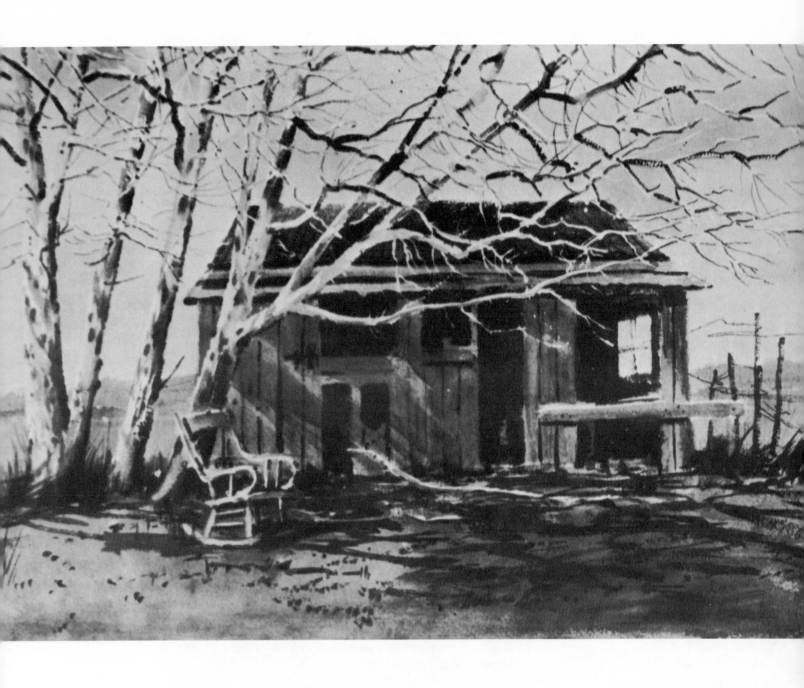

Step 6. Using a Number 8 brush, paint the sycamores, starting at base of the trees with Burnt Sienna, Sepia, and Antwerp Blue, blending colors as you paint skyward. Be sure not to lose the whites and to vary the color, for example, from Antwerp Blue to Burnt Sienna, and to pure Sepia for deep shadows on the right. Paint blotches over the preceding colors with Burnt Sienna and a touch of Sepia.

103

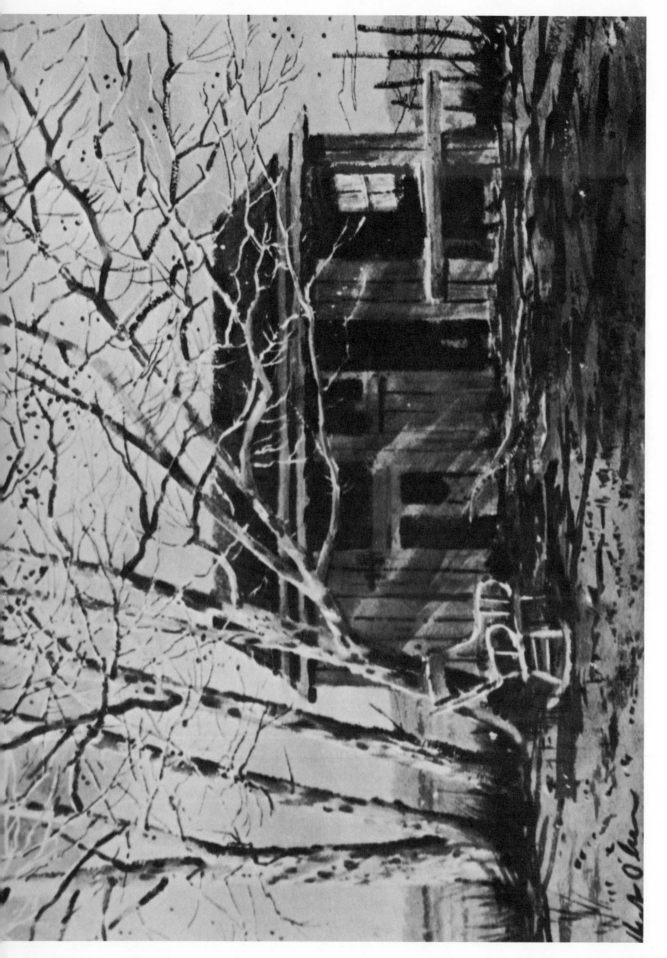

Step 7. Shadows cast on the ground are Burnt Sienna and Permanent Blue mixed on the palette. Use the Aquarelle with a stabbing motion, as demonstrated on page 10, to paint stubby grass over the shadows with Burnt Sienna and Sepia. These colors are neither mixed nor blended, but used directly from the palette.

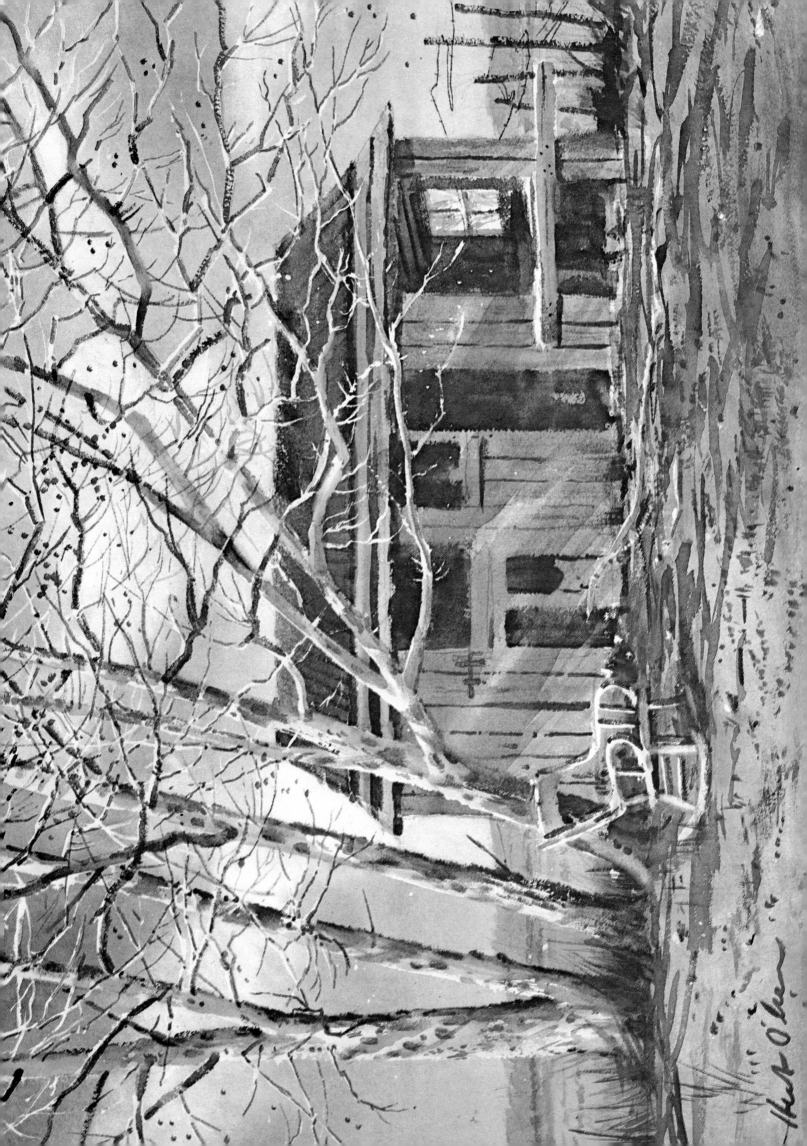

A DESERTED CABIN

106

XVI. AN UNUSUAL METHOD OF PAINTING FOLIAGE

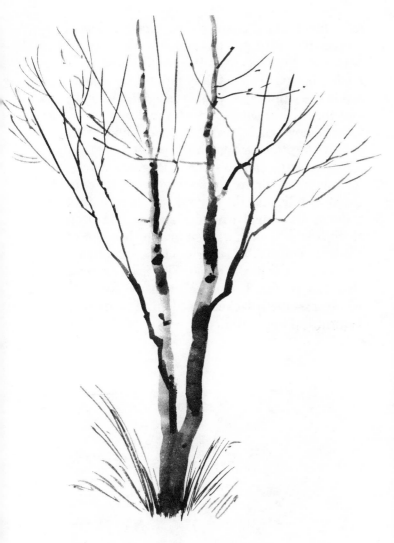

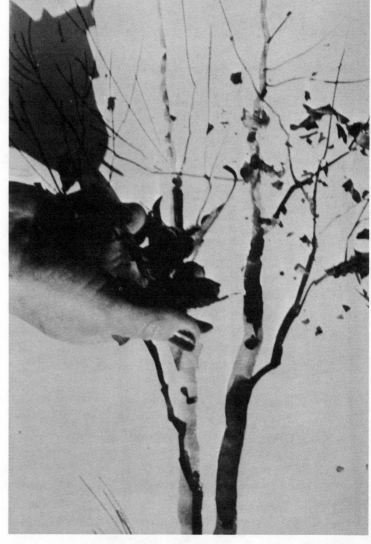

The way leaves have been used on this and the following page is not the "gimmick" it may appear to be at first glance; rather it is an admittedly unorthodox but very helpful method of suggesting patterns of leaves on a model from which to paint a tree.

When painting a tree most beginners are inclined to paint the leaves in a stilted, rather set design without freedom or imagination. In class one day, I was trying to explain to a student the effect to aim for, and in doing so I painted a skeleton of a tree, laid it on the ground, and then crushed a few dried leaves in my hand and scattered the fragments helter-skelter on the paper. The result was amazingly treelike in effect. Shaking the paper on which the "ar-

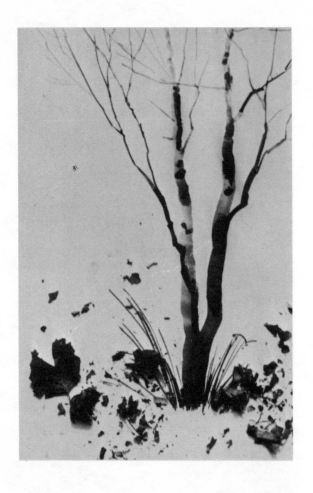

rangement" lies, changes the effect kaleido-scopically and suggests an infinite variety of patterns. Not only can the result serve as a model, but one can actually paint a tree skeleton in the painting, scatter crushed leaves on it, and then, when satisfied with the design, carefully remove each fragment of leaf and paint it in its former position on the paper.

The same can be done with green leaves, for a summer or spring scene, except that instead of crushing the leaves, cut them with a scissors into small irregular shapes and drop them on the skeleton. Then match the color of the leaf—you may be surprised to see how much orange there is in the green. This is an exercise that has proven beneficial to many students whose execution lacked freedom. Try it—it is helpful and fun as well.

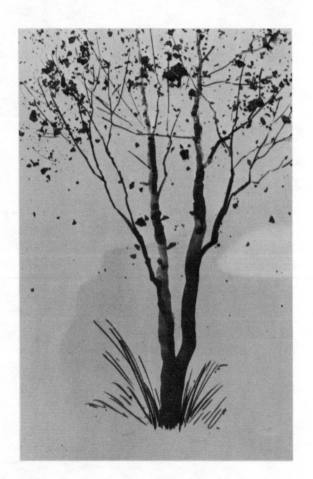

XVII. PAINTING A CITY SCENE

Webster's dictionary defines a landscape as "a portion of land which the eye can comprehend in a single view, especially in its pictorial aspect. 2. A picture representing inland natural scenery." Technically, these definitions confine landscape, more or less, to rural, pastoral, and mountain scenes; accordingly, most of the material in this book is devoted to subject matter of this kind. However, I feel that the whole picture of landscape is not complete without at least a mention of city scenes. They are an integral part of the composite scenery of our beautiful country and offer many artists much very paintable subject matter within easy access.

The physical aspects of painting city scenes, especially in large metropolises such as New York, Chicago, or San Francisco, obviously present special problems of their own such as traffic and crowds—unless one is fortunate enough to hit the city deserted on a holiday. Generally speaking, however, we must rely on the camera, on-the-spot rough sketches, and color notes to furnish the details from which the painting will be made.

The painting procedure does not differ from that used for any other type of subject matter; start with a good drawing and paint from light to dark.

On pages 110-114 are several examples of city street scenes I painted for the Equitable Life Assurance Company. They may be helpful in suggesting various aspects of the big city landscape.

WASH DAY, shown in color on page 116, is another example.

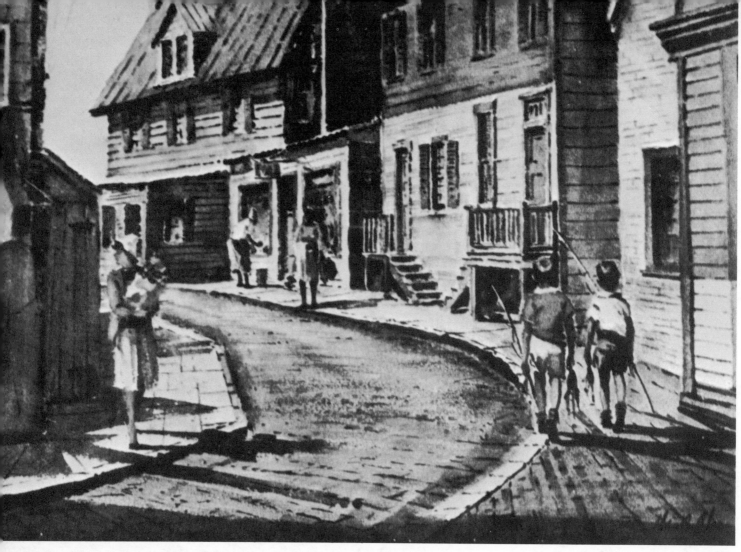

Taylor Street, Annapolis, Maryland.

Baby Sitter, New York.

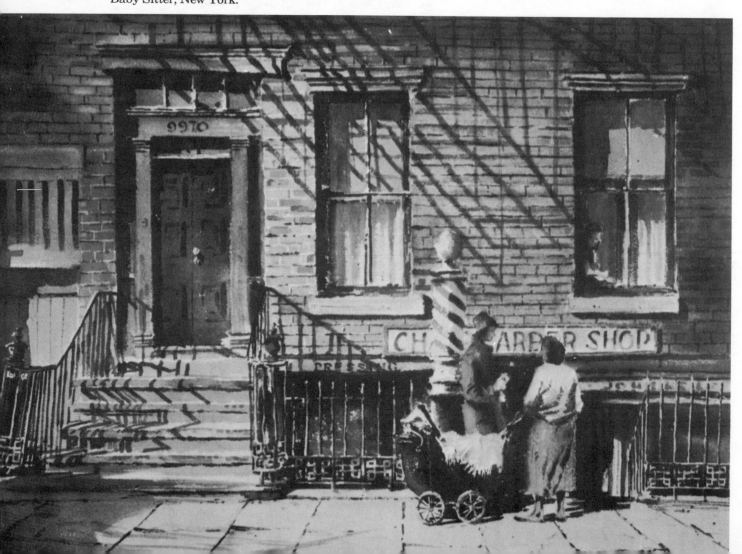

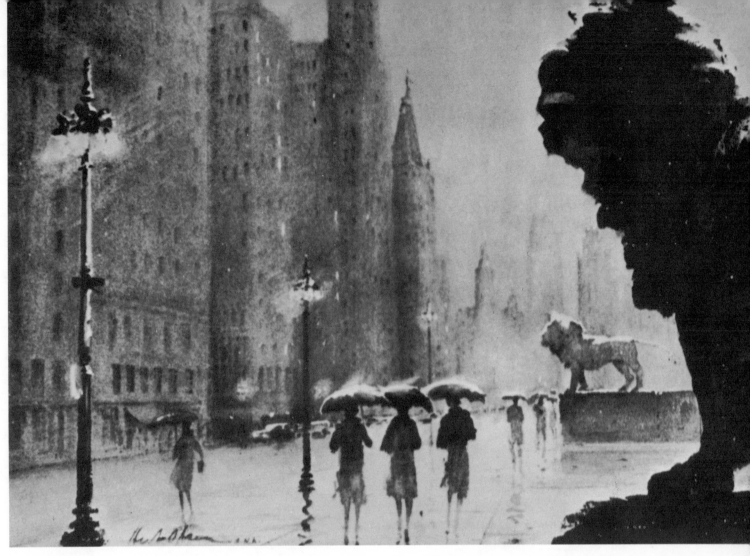

Michigan Boulevard, Chicago, Illinois.

Wall Street, New York.

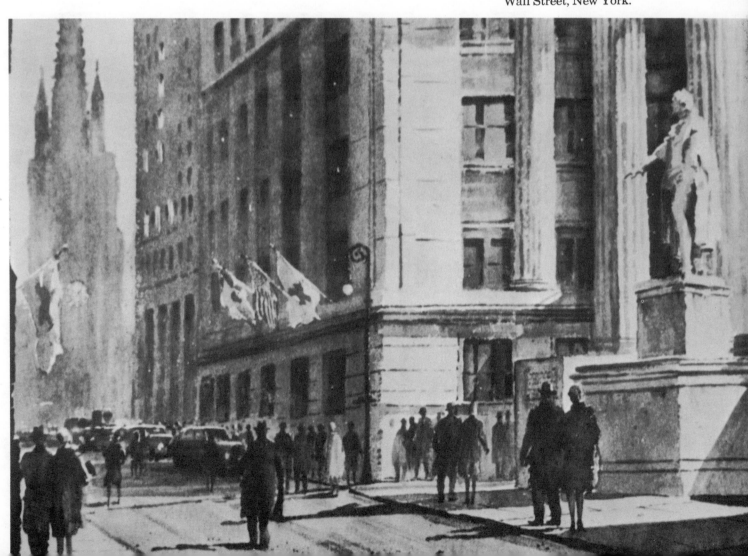

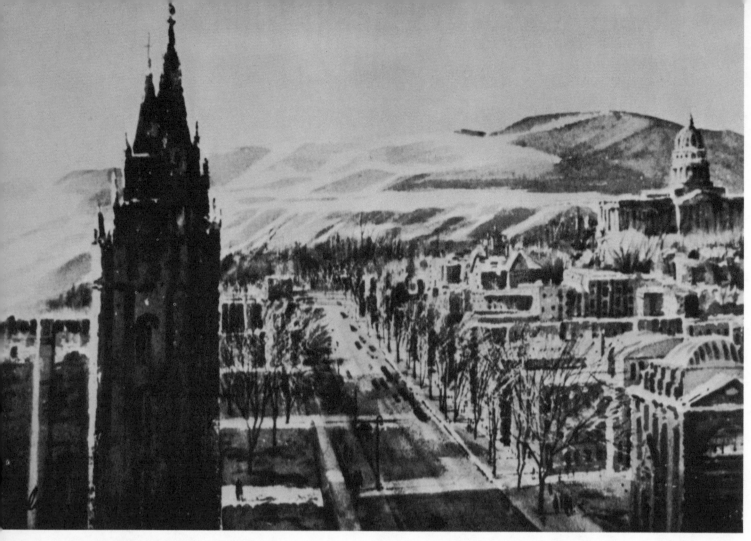

Main Street, Salt Lake City.

Grant Avenue, Chinatown, San Francisco.

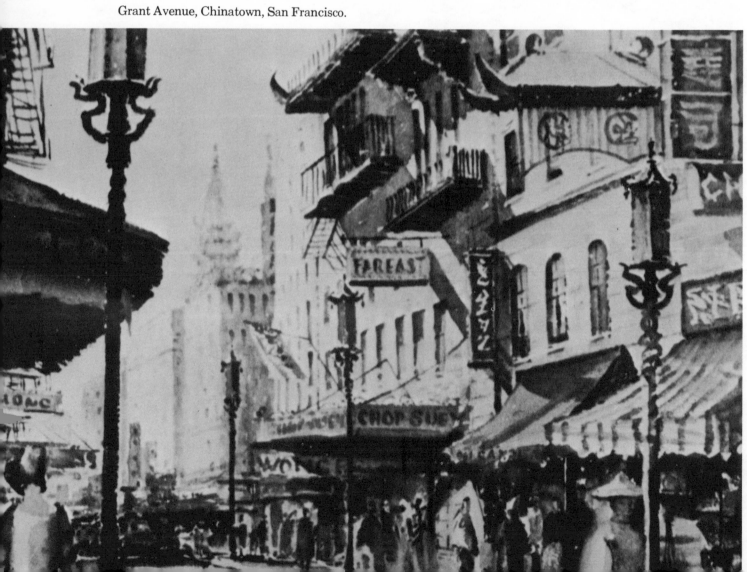

Avilles Street, St. Augustine, Florida.

Bourbon Street, New Orleans, Louisiana.

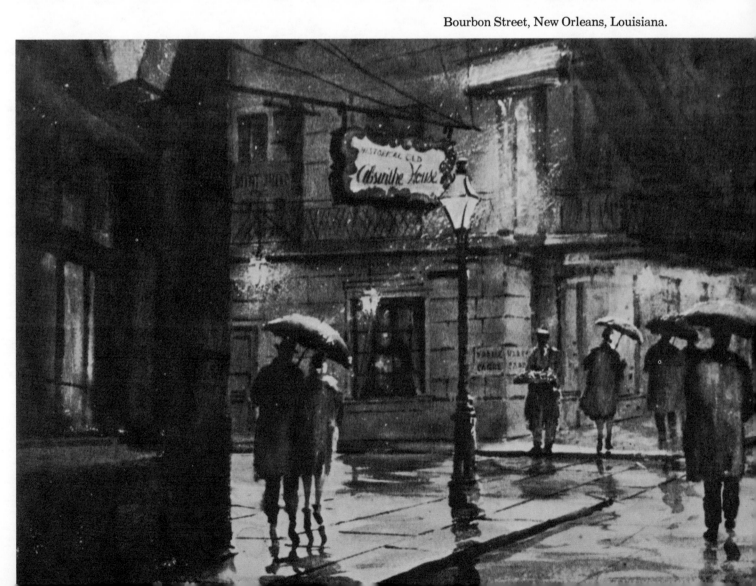

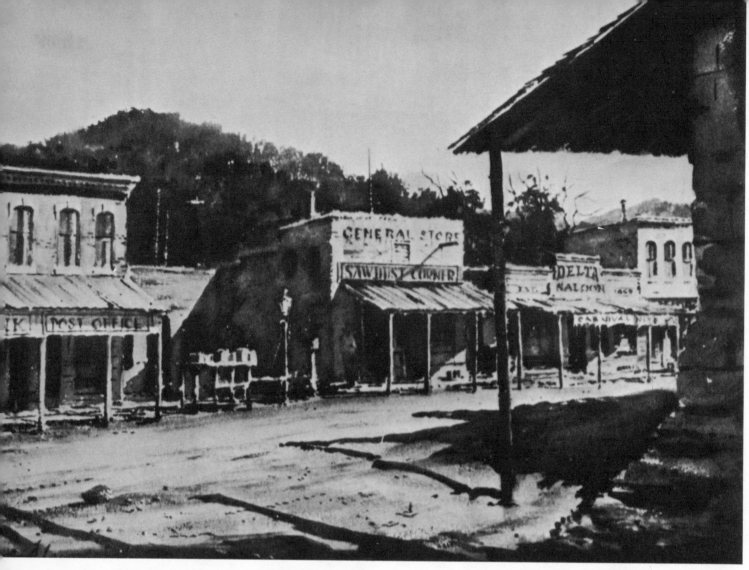

Main Street, Ghost Town, near Bisbee, Arizona.

Prince Street, Alexandria, Virginia.

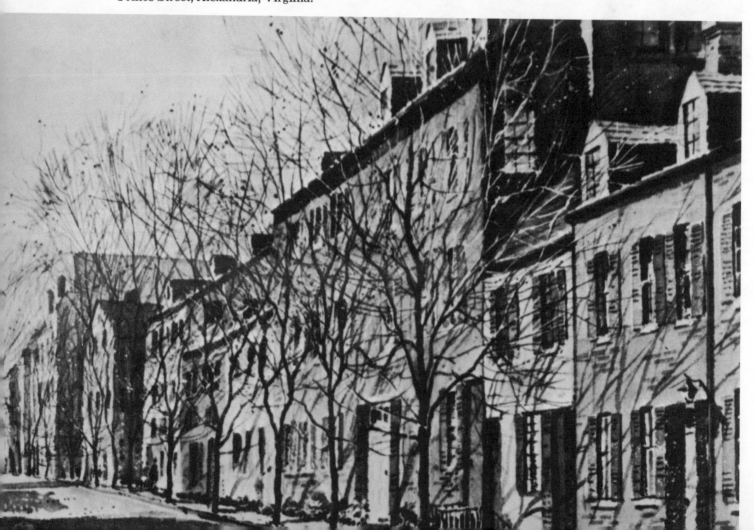

WASH DAY

Herb Olsen A.W.S.

BEACHED →

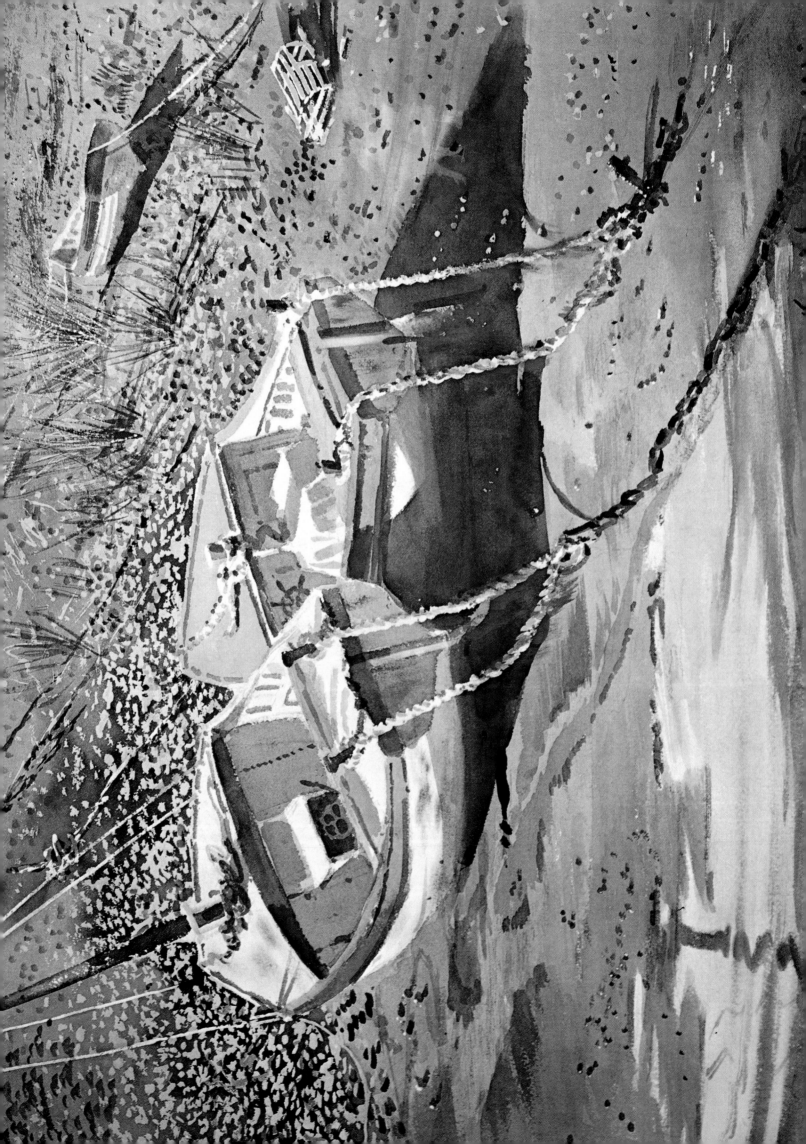

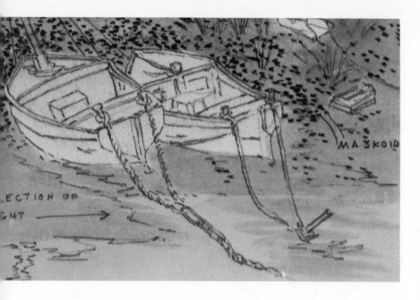

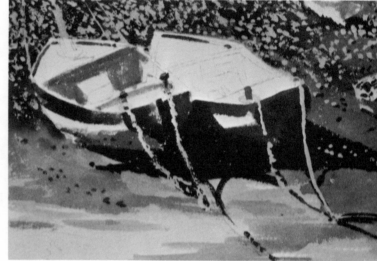

XVIII. BEACHED

Although calling BEACHED, opposite, a "landscape" could be challenged, I personally feel that the beach and its paraphernalia are a very definite part of landscape painting. The boats could easily have been replaced by an old shack, changing the scene entirely, but I chose to leave them in chiefly because painting attached ropes and chains, judging by the many questions asked by my students, presents a "knotty" problem. See page 123 for another example.

The beach area illustrates how I paint small stones en masse. Whether they are in this kind of locale, on a road, or in a field, the same simple method of painting is used.

Here are the materials I used for this picture. D'Arches 300-pound paper, HB pencil, Aquarelle and Number 8 brush, Maskoid, and the following colors: Permanent Blue, Yellow Orange, Burnt Sienna, Orange, Yellow Ochre, Sepia, Hooker's Green, Indian Red. My painting procedure follows.

The two sketches on this page show how the first stages of the stony area were painted. First a light wash of Permanent Blue, Yellow Orange, Burnt Sienna, and Orange was applied over the drawing of the stony area. The Maskoid was applied in dots, singly and in groups, for the stones. Maskoid was also applied on the ropes. In the first illustration I have omitted showing Maskoid applied on the ropes in order to show how carefully the ropes were drawn. When the

Maskoid was dry, I painted dark washes of Permanent Blue and Burnt Sienna on the left side with an Aquarelle brush, working into Yellow Ochre and Blue, lighter on the right side. When this area was dry, I removed the Maskoid and accented the darks of stones here and there with Sepia and Burnt Sienna.

For the foreground I used the Aquarelle brush to apply a wash of Burnt Sienna blending into Permanent Blue and Sepia around the puddle, which was left unpainted. When the wash was dry, I darkened the left side with Antwerp Blue mixed with Sepia, blending into Burnt Sienna and back to Permanent Blue. While these colors were still wet, I added a touch of Hooker's Green on the left side, near the puddle, and a little on the right side. Shadow areas on the white part of the boats were painted with Permanent Blue and Indian Red, mixed on the palette, using a Number 8 brush. The trim on the boats was painted with Burnt Sienna. When this was dry, Sepia was added for darks. The deck of the boat on the right is Light Yellow Ochre; the shadows cast from the boats are Burnt Sienna, Sepia, and Permanent Blue, mixed on the paper.

To give action to the puddle I used semi-circular strokes to apply a wash of Hooker's Green, Burnt Sienna, and Sepia, leaning towards green, mixed on the palette. The reflection of the mast was added with Hooker's Green and Burnt Sienna, mixed on the palette.

119

XIX. HINTS FOR DEVELOPING
GOOD PAINTING HABITS

Painting habits can be developed very quickly so perhaps a few hints and some words of caution will help you avoid the development of poor habits and guide you in establishing helpful, good painting habits.

1. Try to make it a practice to keep your eyes half-closed a good deal of the time when painting. This is not only a great help generally but is actually an essential in seeing pattern rather than detail. For the same reason it is also most helpful in outdoor painting when you are looking for a piece of subject matter—the patterns are simplified. Values, color, darks, and lights are all brought into sharper focus when the eyes are kept half-closed.

2. Another helpful aid is to look at a picture or a composition through a small hole formed by the thumb and forefinger of your hand. This small aperture serves as a viewer and eliminates all extraneous and distracting elements.

3. Do not force the paint into the paper too vigorously when applying color. The brush should always be held so loosely that a gentle tap on the wrist would knock it out of your hand. Try to surface paint so that should you want to make a correction, the task will be easier.

4. Shadows are the last step in painting a picture. First paint all color areas, then paint all details. Lastly, paint shadows for modeling wherever necessary.

5. Do not put finishing details in any area before all preliminary painting has been completed on the entire picture. Work like a sculptor.

6. When painting an upright object such as a telephone pole, a light pole, a mast, flag pole, or similar isolated, vertical item, always keep your eyes just ahead of the brush. Do not look directly at the brush—look at where you are going not at what you are doing, much as a bicycle-rider does. This way of painting will make it easy to control your brush and keep the object straight.

7. In signing a picture, I have the feeling that it should be signed just like a letter, that is, with a written (painted) signature rather than a lettered one. The placement of it is an integral part of the picture; it should be placed with this in mind. For example, if you have a composition with large, blocky forms it can be relieved by the linear design of a written signature properly placed. It is the general belief that a picture should be signed in either the lower right- or lower left-hand side but this is not necessarily true. Often pictures are signed much more effectively in the upper corner, depending on the composition. In order to visualize better where the signature should be placed, reverse the picture by looking at it in a mirror—the reverse view will make it much easier to decide on the most suitable placement.

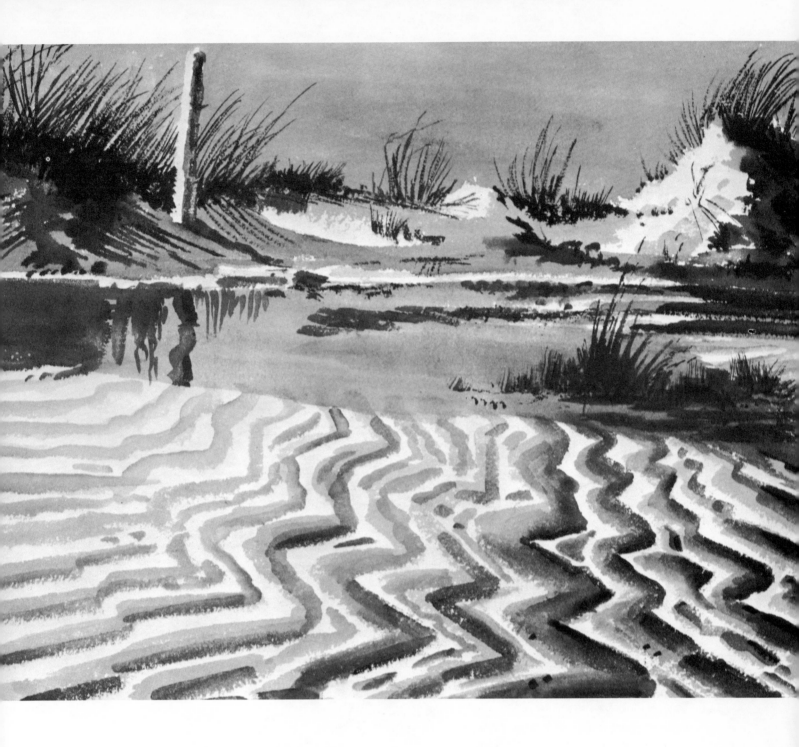

XX. A FEW DIFFICULT ITEMS

Here and on the following pages are solutions to a few isolated problems that are consistently troublesome to students, judging by the questions I am asked most often.

Sand in Ebb Tide. The patterns formed on sand by ebb-tide are first lightly indicated in pencil. In drawing the patterns it is important to establish the horizon line in order to prevent the design from appearing to go uphill. Painting is done in three values. The color of sand, unless it is wet, is usually light orange blending into blue, overpainted with Burnt Sienna in darker areas. Shadows cast on the sand are usually Permanent Blue mixed with a little Sepia.

Barbed Wire. Below is a detailed drawing of wire and a demonstration of how to "wrap" it around a tree or post; also an illustration of how such a small detail as wire can add atmosphere and interest to a painting.

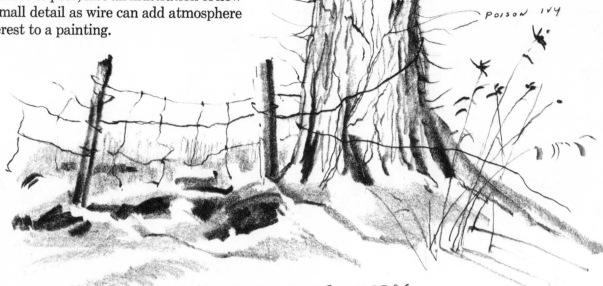

POISON IVY

BARBED WIRE, WEEDS, ROCKS IMBEDDED IN SNOW AND A TREE PLAGUED WITH POISON IVY HAS BEEN A FAVORITE FOR MANY LANDSCAPE PAINTERS. TRY IT!

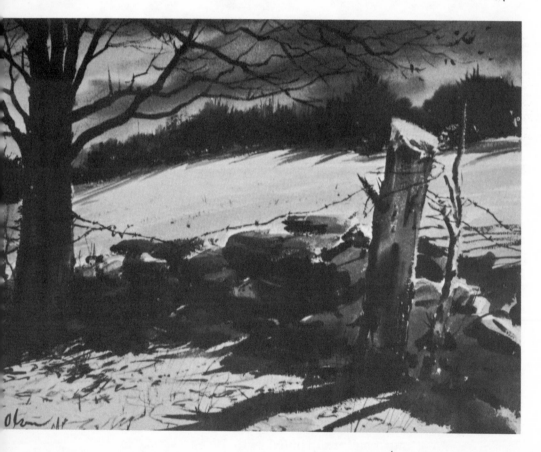

UGLY BARBED WIRE CAN BE ENHANCED BY ADDING A COUPLE OF BIRDS

Chains and Ropes. The first picture shows in detail how ropes and chains are drawn. The second picture shows how they are painted in the rigging of a ship, where they are so often used.

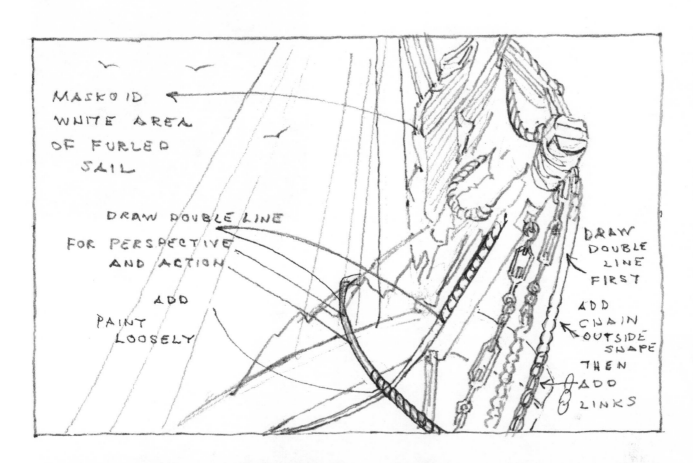

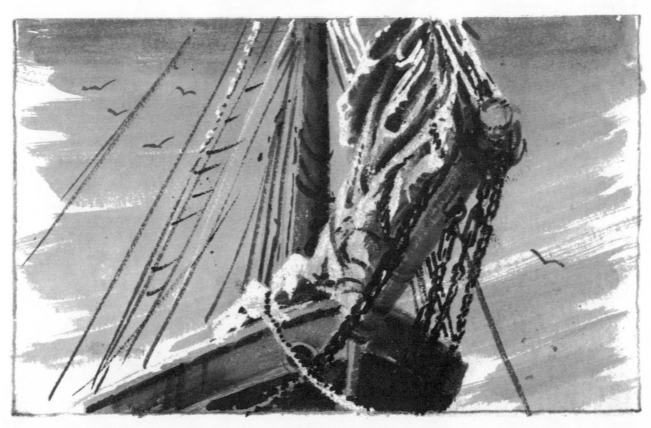

Stairs. These detailed drawings of stairs picture a simplified but foolproof solution for the problem of stairs. The importance of the horizon line is stressed.

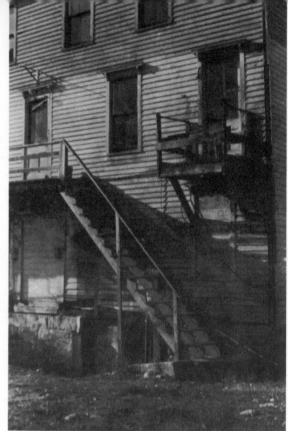

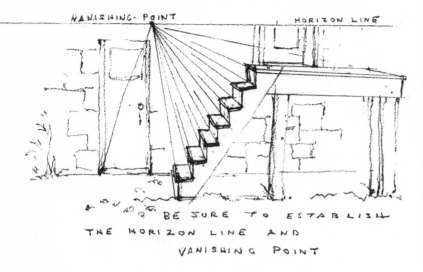

BE SURE TO ESTABLISH
THE HORIZON LINE AND
VANISHING POINT

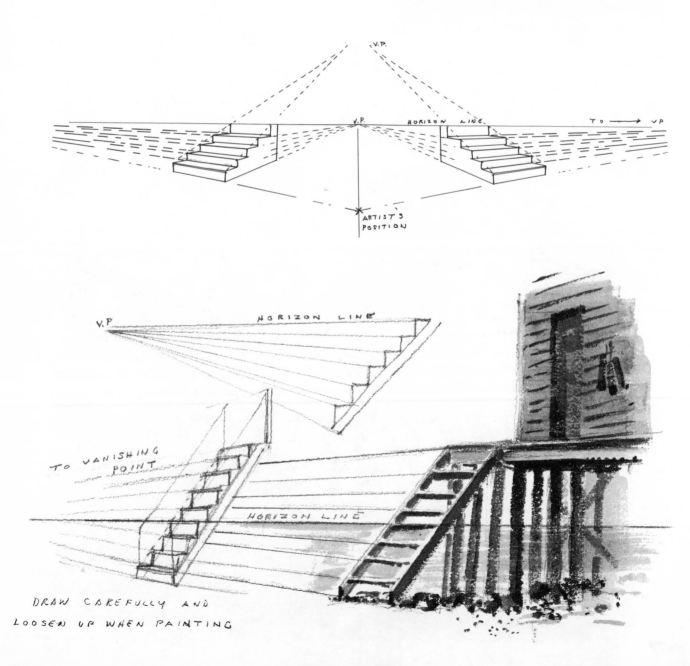

DRAW CAREFULLY AND
LOOSEN UP WHEN PAINTING

A Field of Weeds. Actually this is a one-step proposition although for demonstration purposes it is indicated in four steps and is done in one color. Apply a thin wash over a drawing of the field, and while it is still damp add three graduating values across the field. When dry, add detailed weeds in the foreground.

XXI. WATERFALLS

Waterfalls in general are not only picturesque but also very paintable. They appear to be difficult, but actually they are not. On the opposite page two types of waterfalls are shown—one a turbulent, cascading falls and the other the placid, quietly tumbling falls so often found along a stream or small river. The method of painting the two kinds differs as much as the character of the falls themselves.

In the case of large cascading falls, Maskoid is invaluable. After the drawing has been completed, all the water areas are protected with a coat of Maskoid, carefully applied. When the Maskoid has dried thoroughly, the rocks are painted. When the paint is dry, the Maskoid is removed. The force of the water does not permit reflections in turbulent falls, but slight tints of color should be added to give form to the cascading motion as you can see on the color reproduction of OLD MILL HOUSE opposite.

In painting more placid waterfalls, such as STOUTS' STREAM, opposite, no Maskoid is used. The water is painted first and the rocks last. The whites are areas of the paper left unpainted.

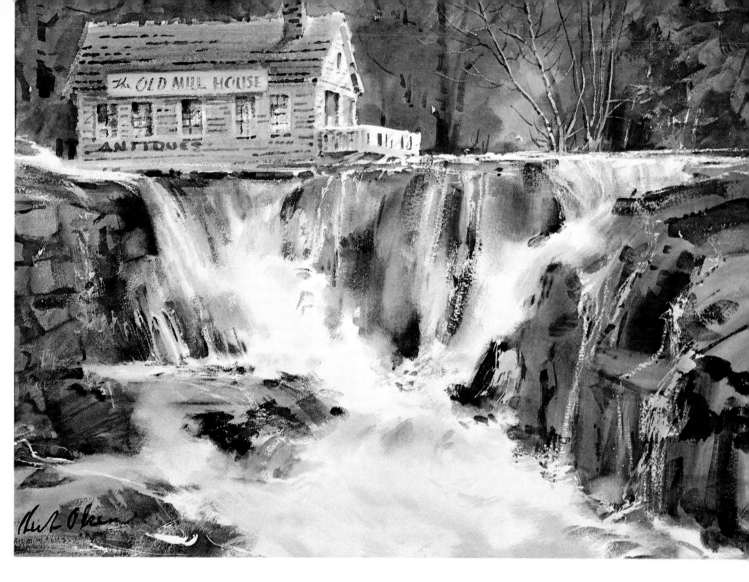

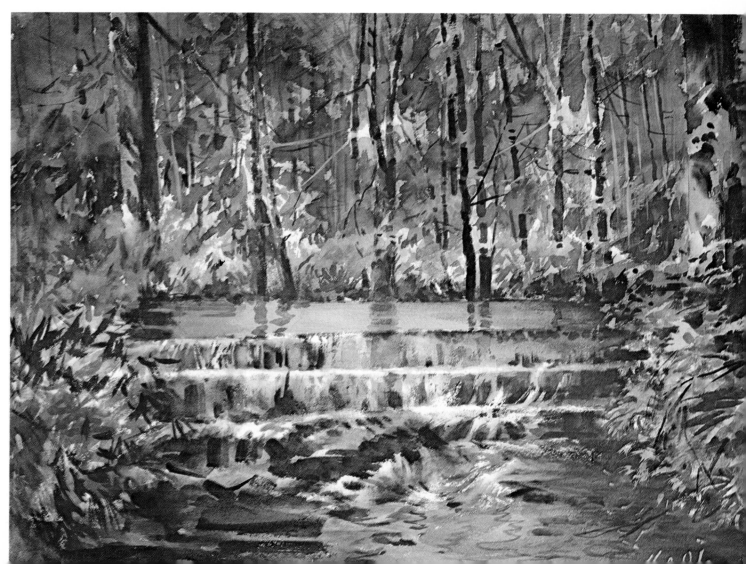

OLD MILL HOUSE

STOUTS' STREAM